C000257560

VICTORIA STATION
THROUGH TIME
John Christopher

AMBERLEY PUBLISHING

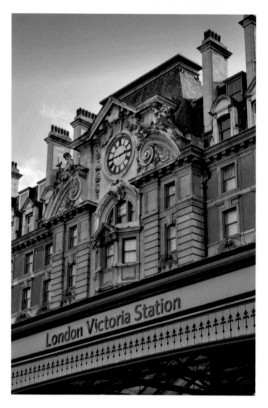

The illustrations in this book enable the reader to explore many aspects of Victoria Station. They seek to document not only its history, its architecture and the changes that have occurred over the years, but also record the day-to-day life of this important railway terminus. Although Victoria has suffered at the hands of the modernisers and developers over the last fifty years or so, its fascinating story can still be traced through its stone, mortar, iron and glass. Consequently there is much to be seen and appreciated to this day. Hopefully, this book will encourage you to delve a little deeper when exploring Victoria Station and its environs, but please note that public access and photography is sometimes restricted for reasons of safety and security.

First published 2011

Amberley Publishing Plc
Cirencester Road, Chalford,
Stroud, Gloucestershire, GL6 8PE

www.amberley-books.com

Copyright © John Christopher, 2011

The right of John Christopher to be identified as the Author of this work has been asserted in accordance with the Copyrights, Designs and Patents Act 1988.

ISBN 978 1 4456 0249 3

British Library Cataloguing in Publication Data.
A catalogue record for this book is available from the British Library.

Typeset in 9.5pt on 12pt Celeste.
Typesetting by Amberley Publishing.
Printed in the UK.

Introduction

Victoria Station is the second in the *Through Time* series on London's famous railway termini. Each of these stations has its own distinctive character, from the Gothic camp of St Pancras's pinnacles to the broad arches of Paddington, and they all express an architectural vision designed to impress the army of travellers who fuelled the great railway boom of the nineteenth century. In their time they were temples to modernity, gateways to the new age of universal mobility. That most of them have survived war, nationalisation, and the unstoppable march of the developers, has more to do with the enormous cost and disruption in replacing them rather than any misty-eyed nostalgia. Miraculously most remain largely intact – with the obvious exception of Euston Station, demolished in the 1960s – and are enjoying a revival in their fortunes, refurbished and celebrated as part of the capital's rich heritage. You could say we have learned to love them again.

London's major stations are also busier than ever with 115 million travellers passing through Victoria alone every year, making it second busiest after Waterloo. Footfall does not relate to critical acclaim however, and back in 1959 railway historian Hamilton Ellis wrote that Victoria's frontage has 'about as much beauty and dignity as a pair of old hags standing with their boots in a Pimlico gutter.' Even Sir John Betjeman, who did so much to encourage an appreciation of railway architecture, confessed that it was a 'rather unhappy sort of muddle.' Viewed from the far side of Terminal Place, Victoria's dilemma is self evident. The frontage suffers from a split personality; a grandiose over-mantle of red-brick and masonry on the right contrasting with a elaborate façade of silvery Portland stone on the left. In fact, it is two stations standing side by side. A bastard child born out of a mishmash of private rail companies and schemes to bring rail access from south of the Thames into central London. Consequently, it was not the result of a grand vision in the same way, say, that the GWR had been, and neither did it benefit from the deft hand of a high calibre engineer such as Brunel. Even so, Victoria has a rich and fascinating history. One spiced with the promise of international adventures.

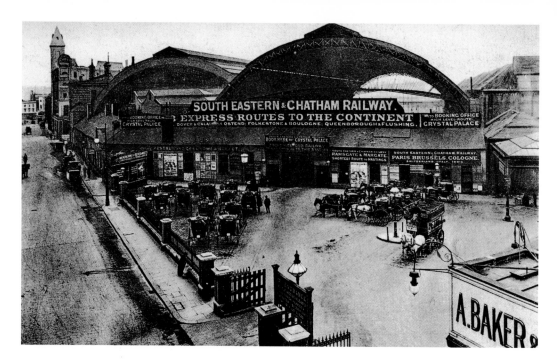

Keeping up with the neighbours

This unusual pair of before and after photographs, looking into the station yard and down Wilton Road on the left, was taken either side of the 1909 rebuild of the old London, Chatham & Dover Railway's frontage. The twin arches of the iron roof are visible in the upper image, although by 1899 management of the LCDR had been amalgamated with the South Eastern Railway to create the South Eastern & Chatham Railway (SECR).

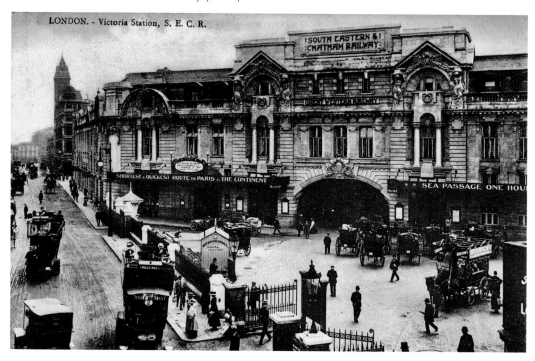

Railway Rivalries

The advance of the railway into west London from south of the Thames came about in a piecemeal fashion through the activities of a number of individual companies. In 1853, the West End of London & Crystal Palace Railway received Parliamentary assent to serve the Crystal Palace newly relocated at Sydenham. This provided the London, Brighton & South Coast Railway (LBSCR) with the opportunity to connect with London & South Western Railway track to gain access as far as the Surrey side of the river. The LBSCR was already operating Brighton trains out of its congested London Bridge terminus and desperately wanted to get into the heart of the untapped West End.

By 1858, the rails had reached a temporary station near Battersea from which passengers were conveyed by horse-drawn carriage over the river on the new Chelsea Suspension Bridge. That same year Parliament passed the Victoria Station & Pimlico Railway Bill permitting the extension of the line over the river following the course of the Grosvenor Canal to a new terminus on the site of the canal basin. This had become redundant when new laws put an end to the practice of taking drinking water from the increasingly polluted Thames. The Victoria Station & Pimlico Railway was collectively owned by four companies, principally the LBSCR and the London, Chatham & Dover Railway (LCDR), plus the London & North Western and the Great Western, the latter two having arrangements to run trains on the lines. Two independent stations were to be built on the 14-acre site, with the LBSCR occupying the western or 'Brighton side' and the LCDR the eastern or 'Dover side'. It should be noted that Victoria Station was not directly named after Queen Victoria, but after Victoria Street, which had thrust westwards from Westminster by the 1850s.

Before any trains could reach the new terminus a viaduct was needed over the river. Grosvenor Bridge, or the Victoria Railway Bridge as it is commonly known, was designed by Sir John Fowler and completed in just twelve months by mid-1860. It consisted of four segmental, wrought iron arches, each with a span of 175 feet, plus a further 70-foot arch on the land at either side, giving an overall length of 930 feet. The first rail bridge to cross the Thames, it carried two lines of mixed standard and broad gauge track, although the latter was later removed to allow for a third standard line. These facilities soon proved to be woefully inadequate and improvements were instigated under the direction of LCDR engineer Sir Charles Fox. The main task was to construct a second bridge alongside and join it to the original creating a 132-foot 6-inch-wide bridge with seven lines. Completed in August 1866, this gave the LCDR independent access to its station.

The LBSCR station was the first to open for business, on 1 October 1860, and according to newspaper reports it did so without ceremony. 'The doors were thrown open, passengers took their tickets, and the trains started as though the line had been in working order for years.' The LCDR followed shortly afterwards, operating out of a temporary station until the main one was ready in August 1862.

From the start each station was run as a separate entity, with its own entrance, booking office, station master, timetable and platform numbering. For the poor passengers it must have been utterly confusing. Architecturally speaking the two stations were chalk and cheese. The LBSCR station had a simple ridge and farrow roof of iron girders extending 800 feet in length, as far as Eccleston Bridge, and 230 feet wide. Originally there were nine lines of rails between four platforms, and a paved road running the length of the station, allowing carriages to enter the south side and exit on the north. Its unimposing frontage had a wide canopy to shelter travellers from the rain and faced onto the triangular station yard on the northern side, now known as Terminus Place. One thing the LBSCR station did have was the Grosvenor Hotel along its western side. Regarded as an integral part of the terminus the hotel was not railway property at first and the LBSCR only became the landlord in 1892.

The rival LCDR train shed, designed by Sir John Fowler, featured a fine pair of elegant arched spans of tied wrought iron construction supported on cast iron columns. By no means the first use of iron and glass, Fowler's roof has a lightness of touch lacking in other station roofs from this period. The company's offices on Wilton Road had a simple canopy adorning a three-storey building in a Georgian style, and access for carriages was from the station yard to the north.

In 1889, the LBSCR instigated a complete rebuild of its station involving lengthening the platforms to accommodate two trains at any one time, a replacement train shed plus an entirely new south shed stretching from Eccleston Bridge to Elizabeth Bridge. The old station frontage was pulled down and in its place arose a grandiose extension to the Grosvenor Hotel in high Edwardian Baroque, completed in 1906. Not to be outdone, the LDCR responded with a distinctive new station frontage of its own, an over-blown vision of Baroque opulence complete with curvaceous carytalids. Clearly, the spirit of rivalry was alive and well.

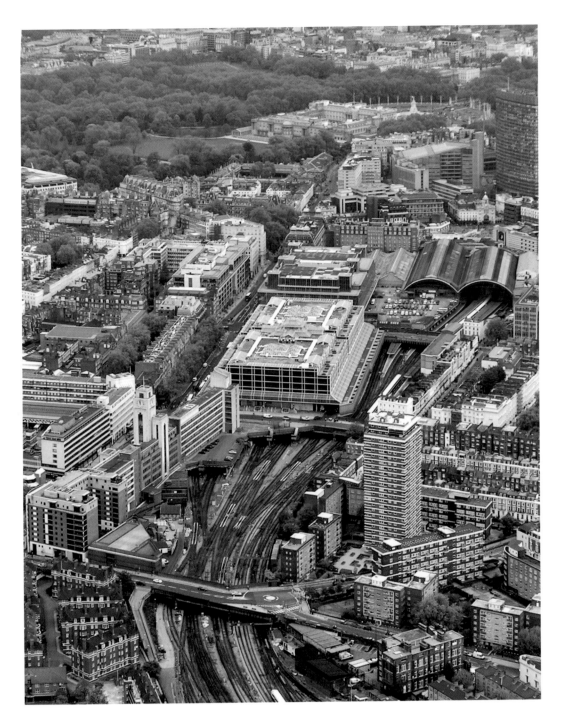

Location

Looking north, this 2007 aerial photograph clearly shows the arches of the LCDR station on the eastern side (right) while the LBSCR station (to the left) is obscured beneath the new buildings. The three road bridges, working southwards from the station, are Eccleston Bridge, Elizabeth Bridge and Ebury Bridge. Buckingham Palace Road, with the Imperial Airways and Coach Station buildings, runs up the left-hand side towards Buckingham Palace. (Network Rail)

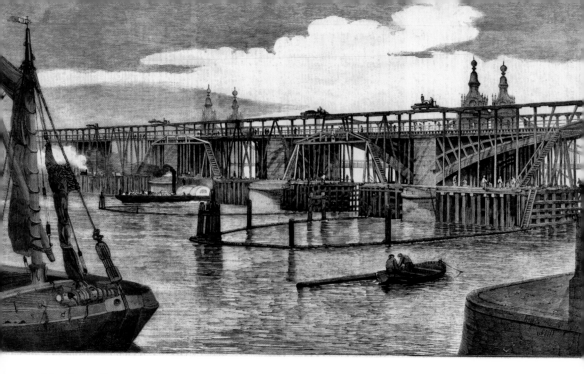

The first railway crossing over the Thames

The key to getting a railway into the West End of London was the construction of the Grosvenor Bridge, or the Victoria Railway Bridge as it is generally known. Designed by Sir John Fowler, the original bridge consisted of four main arches of wrought iron spanning the river itself and was completed in 1860. Six years later it was doubled in width to deal with the increase in trains, and then, in the 1960s, rebuilt in steel and concrete.

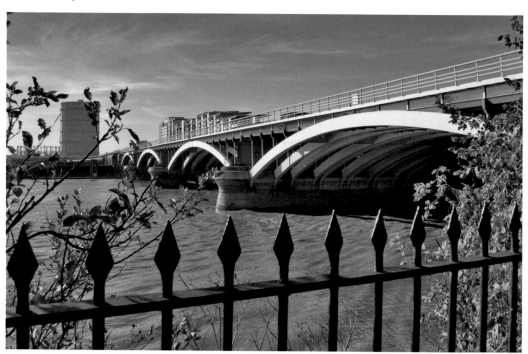

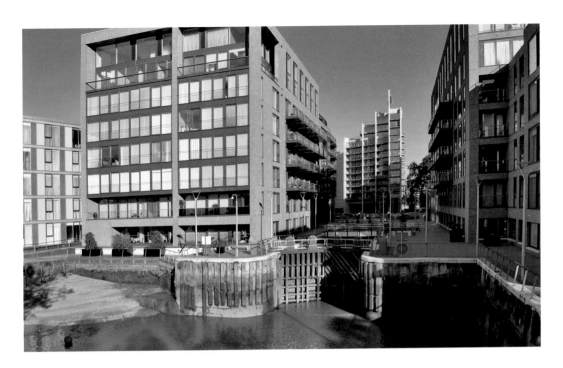

North of the river crossing

The railway follows the old Grosvenor Canal to the station, which was built on the site of the redundant canal basin. The entrance lock from the river is still there beside the Lister Hospital and surrounded by new apartment blocks. Heading towards Victoria the rails descend on a steep 1:61 incline and this early morning view from Ebury Bridge, looking southwards, shows the coach sheds to the left, and Battersea Power Station on the far side of the river.

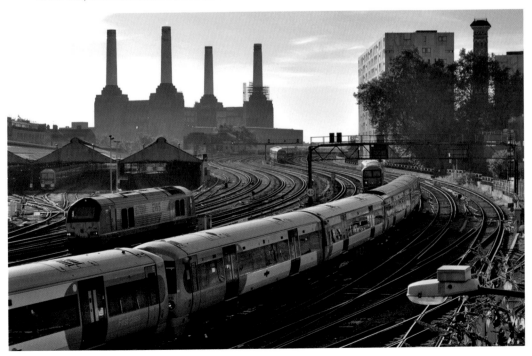

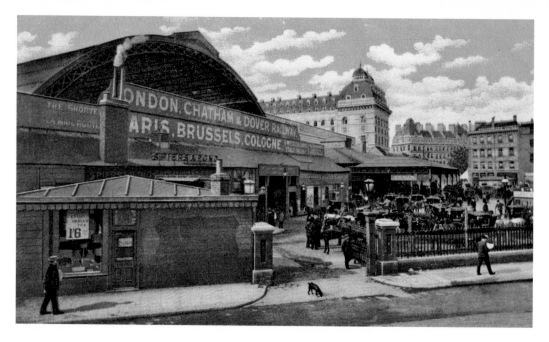

A new look

Originally both railway companies had only a ramshackle collection of buildings facing onto the station yard to the north, now Terminus Place, as shown above in the 1890s. The main entrance to the LCDR station was actually around the side on Hudson's Place, but when the LB&SCR finished its grandiose new frontage in 1908 the LCDR, or SECR by that time, felt obliged to follow suit. Not only that, they hoped to upstage their rivals with this Baroque-inspired frontage completed in 1910.

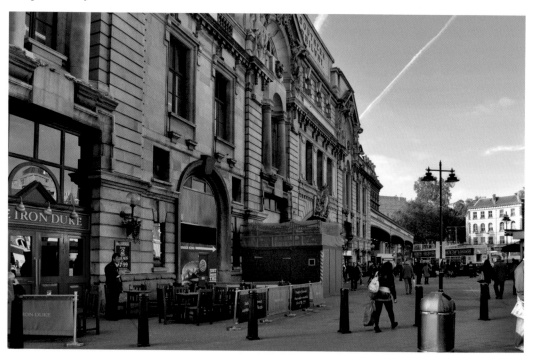

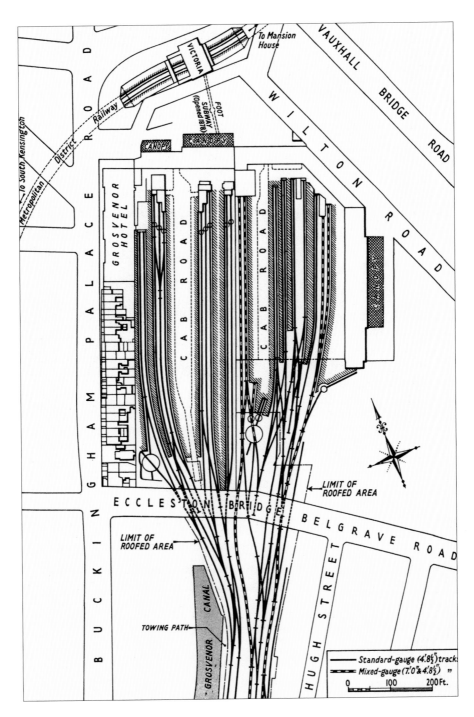

1869 plan of Victoria Station

This pre-dates the rebuilding of the LBSCR station with its additional train shed south of Eccleston Bridge. Note how the site is restricted by buildings on Buckingham Road to the west, while on the far side the original entrance of the LCDR is on Hundson's Place leading off Wilton Road. The Metropolitan District Railway on the north was linked to the mainline station by a subway in 1878.

11

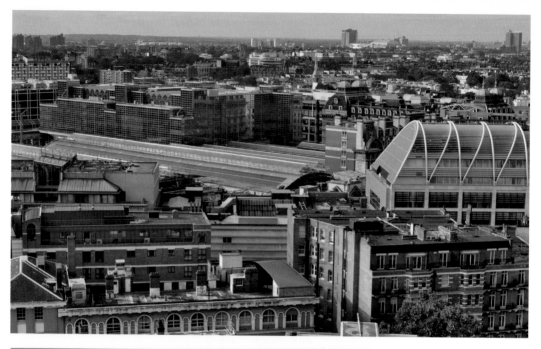

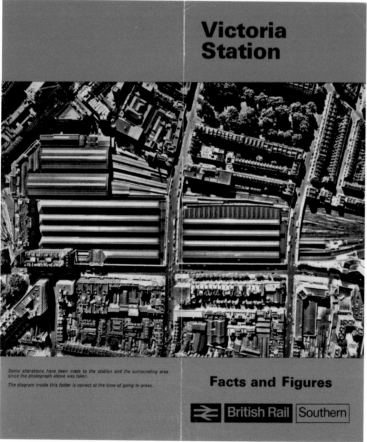

Victoria Station

Some alterations have been made to the station and the surrounding area since the photograph above was taken.

The diagram inside this folder is correct at the time of going to press.

Facts and Figures

≷ British Rail | Southern

A changing landscape British Rail, Southern, published this information leaflet in the early 1960s and its cover photograph clearly shows the twin spans of the SECR roof shown in their shortened post-war state, and the rectangular train sheds of the LBSCR station stretching all the way to Elizabeth Bridge. In the more recent photograph, above, the arched spans are still visible, but the other sheds have disappeared almost completely under a new shopping centre and offices.

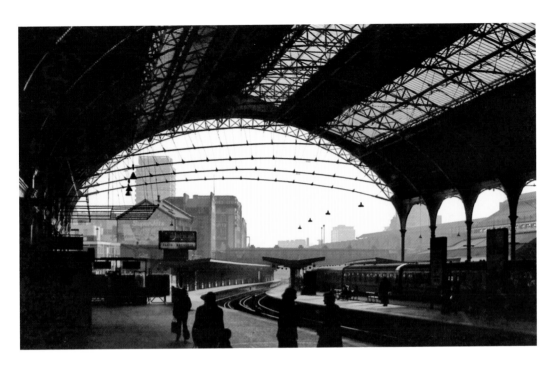

LCDR train shed roof

The elegant curves of Sir John Fowler's wrought iron arches photographed in 1976 by Pete Hackney. They remain one of the finest examples of Victorian engineering of the period and their lightness is evident in the 2010 close-up. Note the sign for the Night Ferry. This is now displayed in the National Railway Museum.

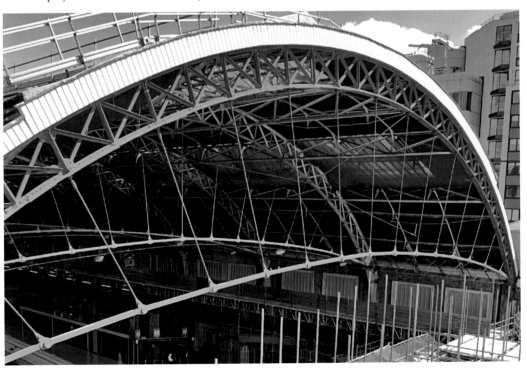

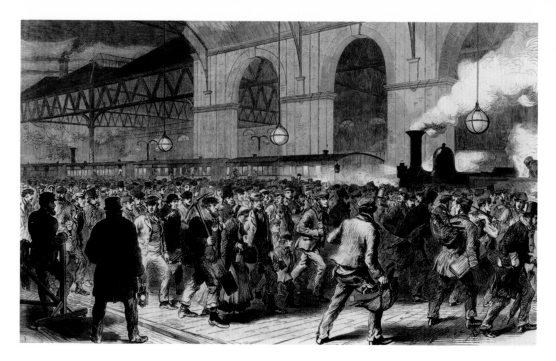

The workmen's Penny Train

In 1865, Victoria became the scene of an interesting social experiment which enabled workmen to travel on two trains daily, either on their way to work or going home, at the special weekly ticket price of one shilling. Ironically, it had been the coming of the railways that had forced many workers to move away from central London in the first place. For today's workforce commuting has become a way of life.

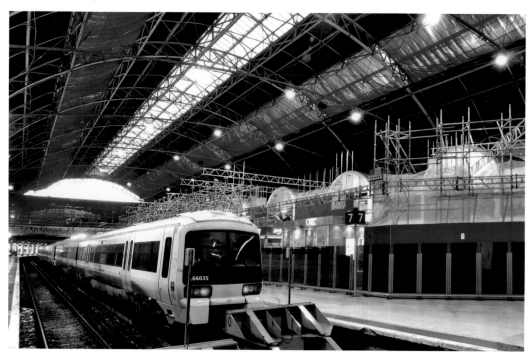

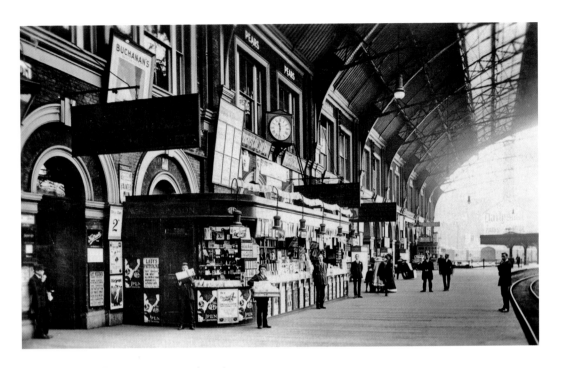

W.H. Smith, newsagents and stationers

This booth on the SECR platform sold all manner of newspapers and magazines for railway travellers in Edwardian times. Prominently displayed are the *Lady's Pictorial* and *London Opinion*. Inevitably there was a similar shop on the LBSCR station next door. Today's equivalent is the largest of the company's London station outlets and its design mimics the curves of the Crystal Palace as it pierces the arches in the old dividing wall between the two stations.

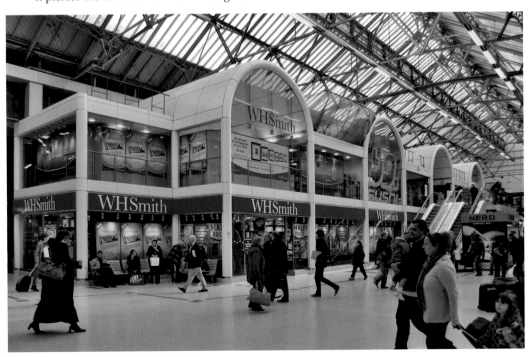

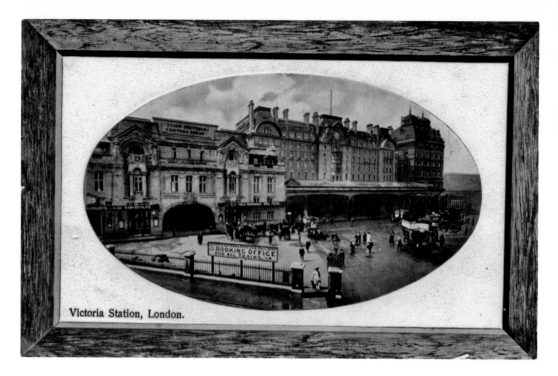

Victoria Station, London.

Station frontages

The contrast in architectural style between the two railway rivals is as plain to see now as it was in this photograph taken shortly after the new SECR frontage, on the left, had been completed in 1910. The lone motor bus among the horse-drawn buses and cabs in the station yard indicate that this was pre-First World War. Apart from changes to the company names, the façades have survived remarkably unaltered over one hundred years later.

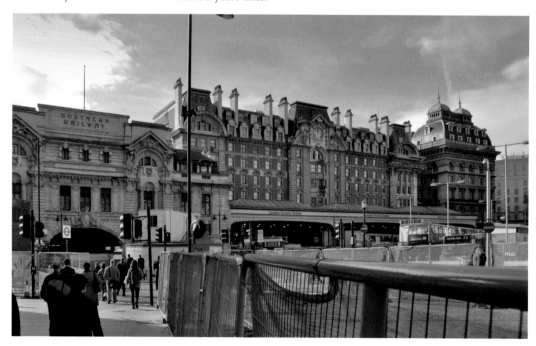

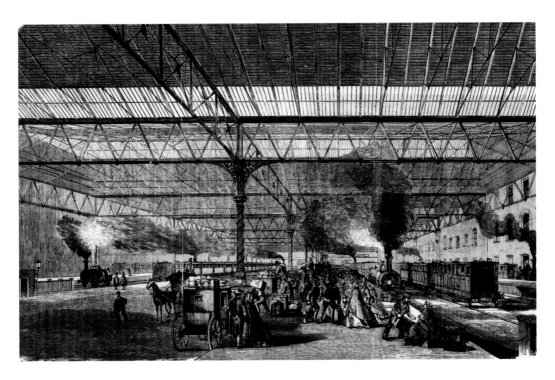

The LBSCR 'Brighton side'

The Illustrated London News of May 1861 shows the newly opened Victoria terminus 'at Pimlico' – a hangover from the old name for the area. This is the LBSCR or Brighton side of the station and features the original roof before the major rebuilding work at the turn of the century. There are nine lines of rails between four platforms, and note the wide central area for horse-drawn carriages.

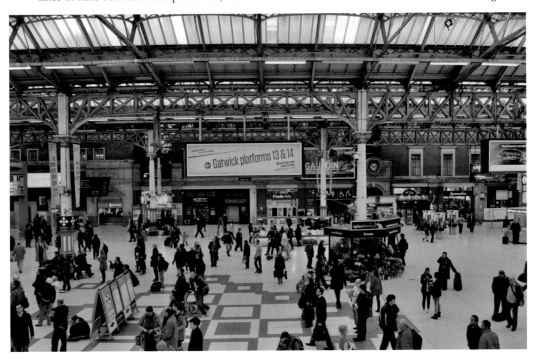

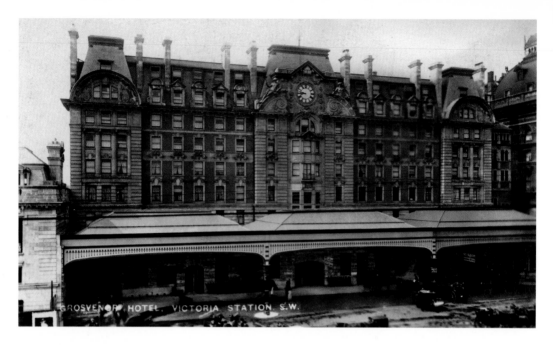

The LBSCR's frontage

For many travellers the LBSCR building is the face of Victoria Station. Designed by Charles L. Morgan and completed in 1908, its upper storeys contain an annexe to the Grosvenor Hotel which is why it so closely mimics its styling. Beneath the French mansard roofs the red-brick is alleviated by ashlar end pavilions and a centrepiece featuring a clock flanked by reclining statues. The overall effect is a glorious expression of Edwardian pomposity which has been unkindly likened to a 'gigantic overmantel'.

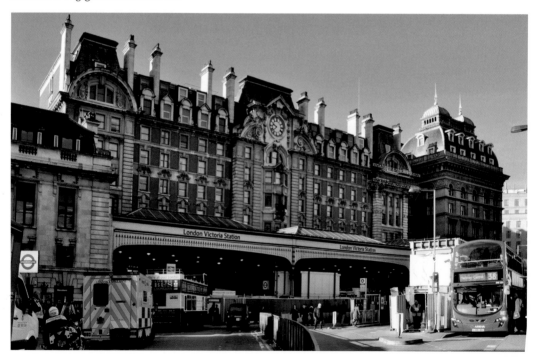

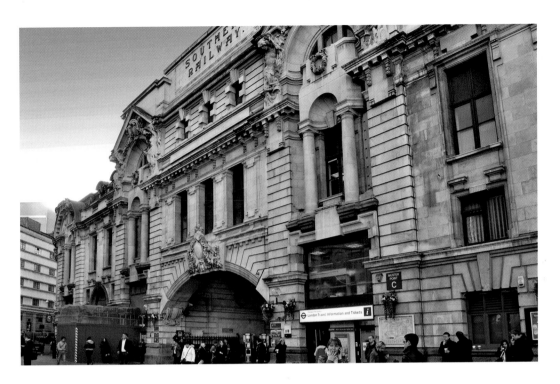

The SECR retaliates

If the SECR could not compete with its new nine-storey neighbour in terms of scale, then its designers, Alfred W. Blomfield and W. J. Ancell, resolved to out-style it with all the architectural bling at their disposal. Completed in 1909, the result was a catalogue of elements including a wide archway, ionic columns, pediments and four busty mermaids. Inside was the sumptuous Continental Restaurant where diners could have lunch or take supper for one shilling and sixpence, or dinner at two shillings and sixpence.

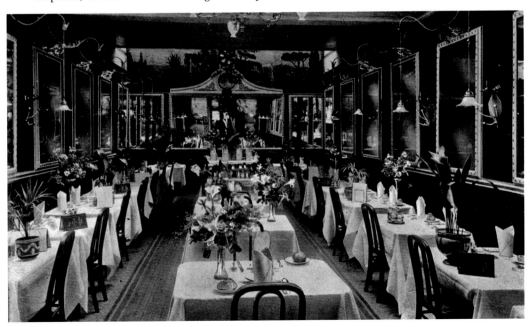

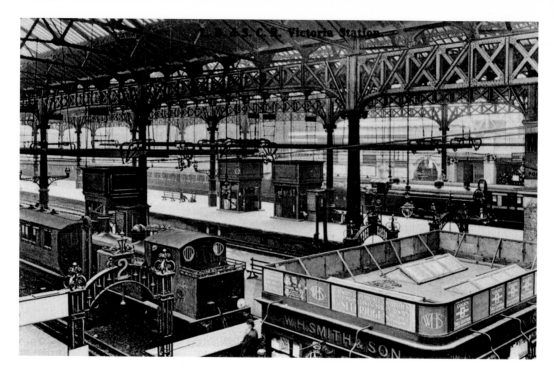

LBSCR interior

The main train shed on the Brighton side, as rebuilt between 1900 and 1908. It consists of five ridged roofs with deep lattice girders supported on cast iron columns and by the surrounding buildings. In this photograph, from before the 1923 grouping of the railways, this station has its own platform numbering from east to west. The old platform gates have gone and a much larger concourse area has been created by moving the end of the tracks further back.

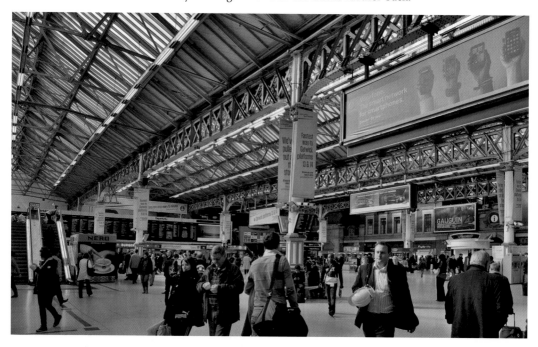

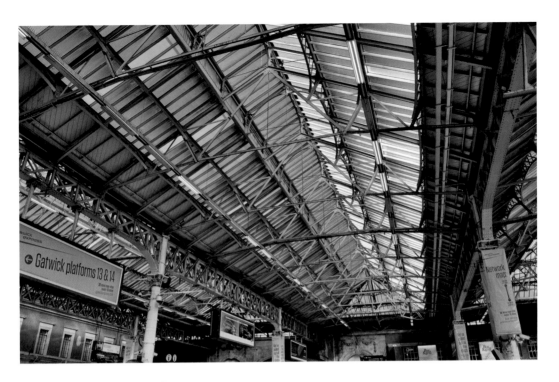

LBSCR train shed roof

The detailing of the roof is shown here, looking back along the ridge towards the station buildings. In the 1980s, the roof was severely truncated on the southern end as part of the redevelopment of the site and it now only covers the head of the platforms. From the outside you can actually stand in the car park area, almost on the same level as the internal lattice girders, to see the profile of the roof where it was chopped.

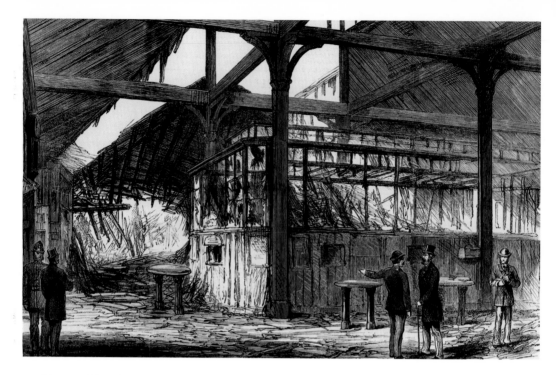

Bookings and bombings

In February 1884, seven people were injured by an explosion at Victoria Station which caused extensive damage to the booking office, waiting room area and cloak room. It had been caused by a bomb planted by an Irish-American group. History repeated itself in February 1991 when an IRA bomb killed one man and injured thirty-eight. The new booking office is shown below.

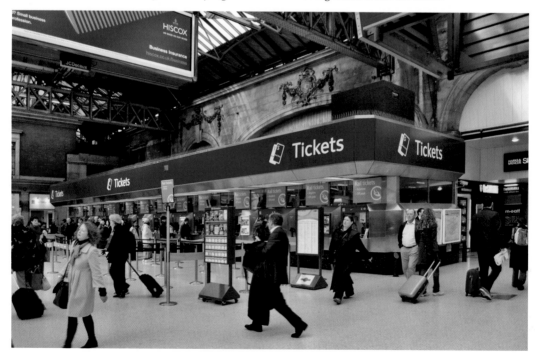

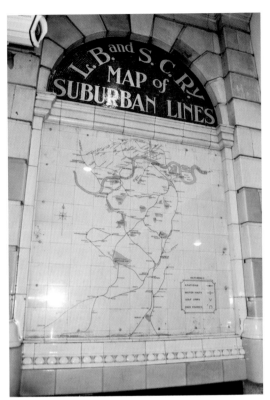
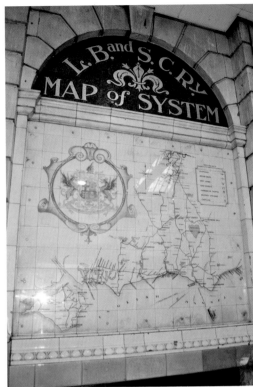

Map of the system

These maps made in ceramic tiles are situated within one of the entrances to the former LBSCR station and show the extent of the company's system and also the suburban lines. In the scene below, members of the Corps of War Artists wait for a train to the 1881 Easter Volunteer Review held in Brighton.

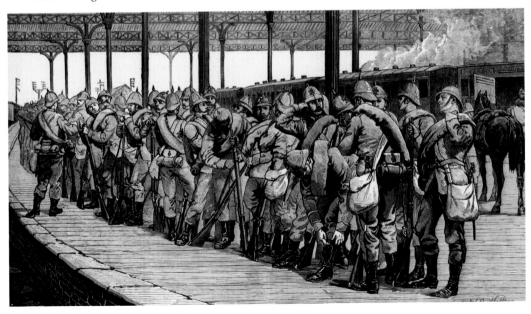

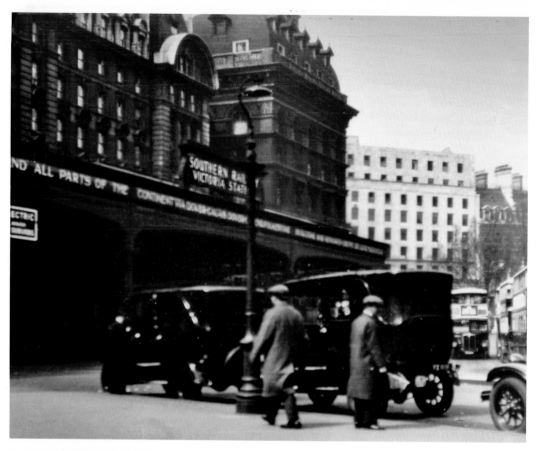

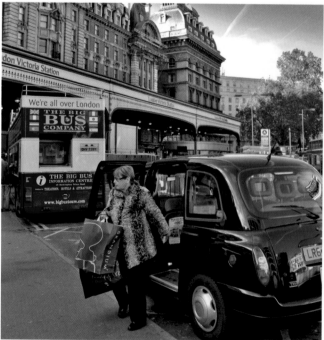

Road and rail
Some scenes never change.
Travellers arriving at Victoria
by taxi to catch a train.
Note the sign for 'Southern
Railway Victoria Station' in
the upper image from the late
1930s.

Vehicle entrances

The entrance for vehicles for the SECR was from the station yard, while the old entrance to the LBSCR station, shown below, was off Buckingham Palace Road next to the Grosvenor Hotel. Note the company coat of arms above the doorway and the office block behind the gateway. The station's own News Theatre cinema was behind the gateway and the entrance was through the arch to the right. This screened a continuous programme of news reels and travel films.

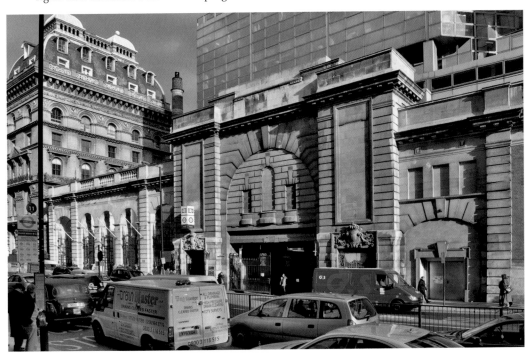

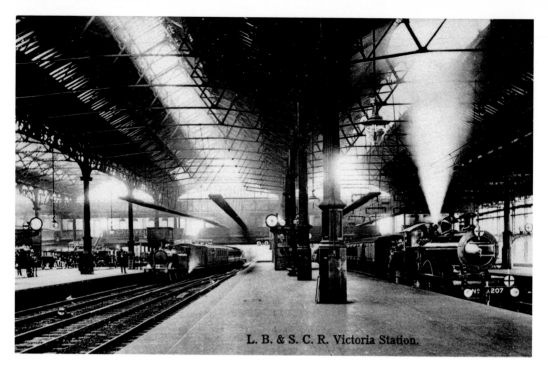

L. B. & S. C. R. Victoria Station.

Train sheds

A busy LBSCR south train shed *c.* 1910. Note the stairs providing pedestrian access to the Eccleston Bridge in the background, and a row of motor taxis lining up on the cab road on the left. The only remaining section of the north train shed roof covers the modern concourse area.

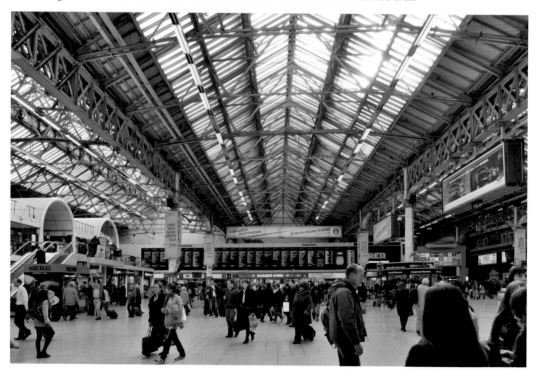

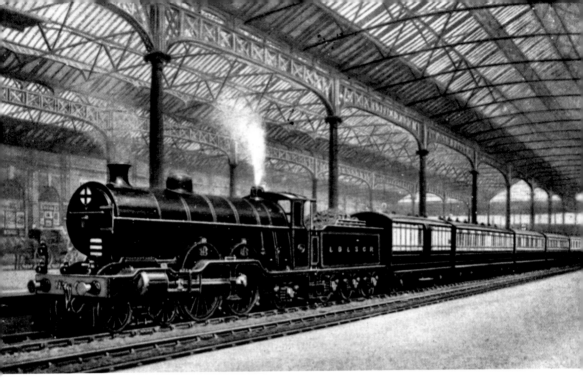

Express trains
A postcard from the 1920s of an LBSCR Southern Belle express, a 4-4-2 H2 class locomotive in the company's distinctive brown livery. One modern equivalent is the colourful Gatwick Express, a British Rail Class 460 Electrical Multiple Unit, of which only eight were built. This runs between Victoria and Gatwick Airport every fifteen minutes and is operated as part of the South Central Franchise. This is 08 arriving at Platform 13 in 2010.

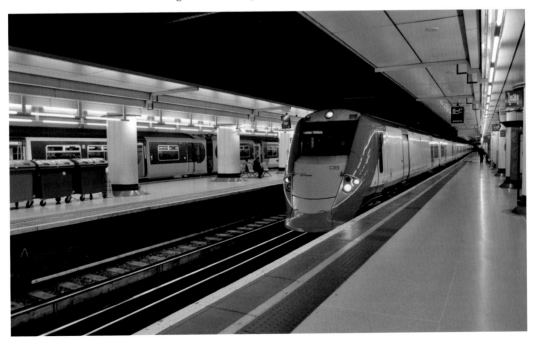

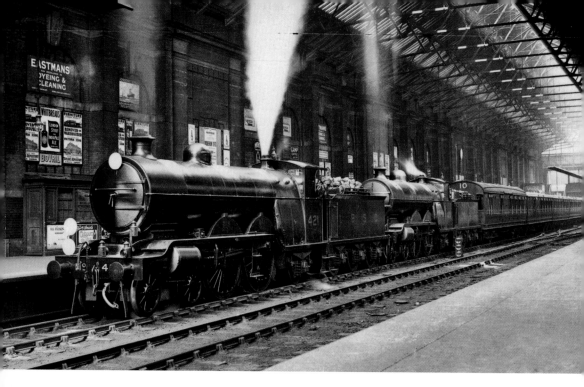

LBSCR locomotives

A superb view of a double-header waiting at Victoria. The lead loco is No. 421 *South Foreland*, an H2 class designed by D. E. Marsh of which six were built at the Brighton Works between 1911 and 1912. Below is No. 584 *Lordington*, a 0-6-2T E5 class tank engine, designed by R. J. Millington and built in 1903 for suburban and country trains. This loco had a long career and was not withdrawn by British Railways until 1951.

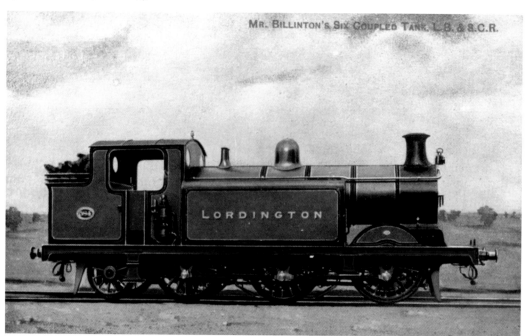

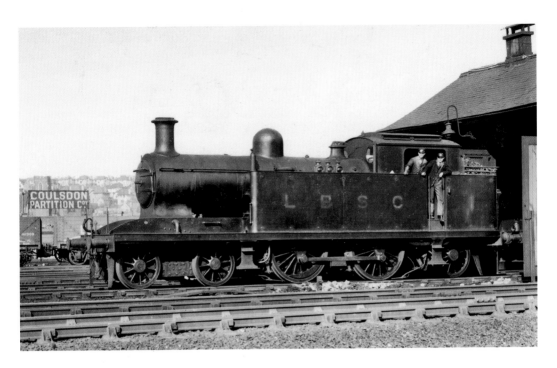

LBSCR tank engines

Above is a 4-4-2T at Coulsden, either an I2, or the I4, which was the same design as the I2 except that it incorporated a superheated boiler. These tank engines were designed by D. E. Marsh and built at Brighton between 1907 and 1908, but they were short-lived being withdrawn by Southern Railway in the 1930s. Below, is No. 662 *Martello*, an A1 class 0-6-0T. Introduced in 1872, the A1 class were designed by William Stroudley to haul commuter trains (photo Nick Fowler).

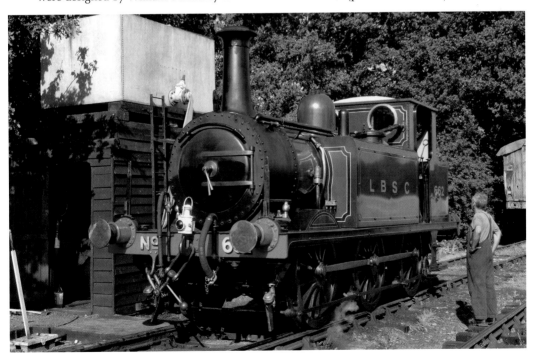

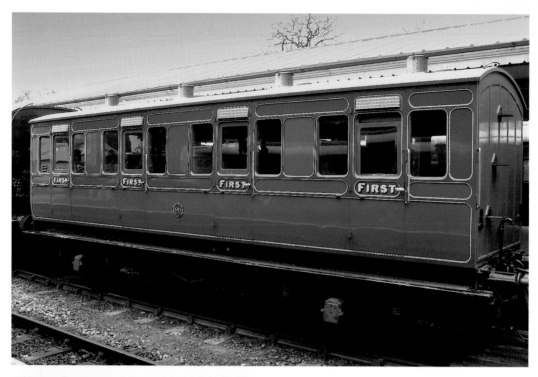

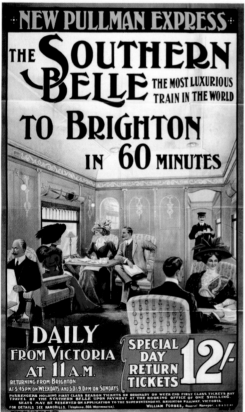

LBSCR coaches

A First Class four-wheeler coach, No. 661 (photo Peter Skuse). These could not match the level of comfort to be expected on board a Pullman express as portrayed in this poster for the Southern Belle, 'The most luxurious train in the world'. The modern health and safety brigade would have a fit at the thought of passengers sitting on unsecured furniture aboard an express train. Originating in the USA, the Pullman name represented the epitome of comfort in rail travel and the first Pullman coaches for British rails were assembled at Derby in 1874. The LBSCR was among one of the earliest companies to adopt the coaches when it introduced the drawing-room Pullmans on some Brighton services from 1875.

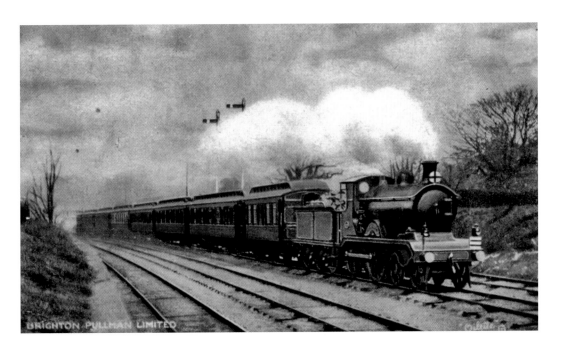

Pullman services

This postcard depicts the Brighton Pullman Limited with a number of carriages in the old brown colours. In 1903 the LBSCR changed its ordinary coaches to umber brown with cream upper panels, and this scheme was adopted by Pullman in 1906. Today, the Venice Simplon Orient Express (VSOE) still operates with restored Pullman coaches, mostly from the former Brighton Belle service. The trains depart from Platform 2 for destinations on the Continent or for day excursions within the UK. Below, an EWS Class 67 diesel electric loco is on its way back into Victoria after a VSOE 'special' to Leeds Castle in Kent.

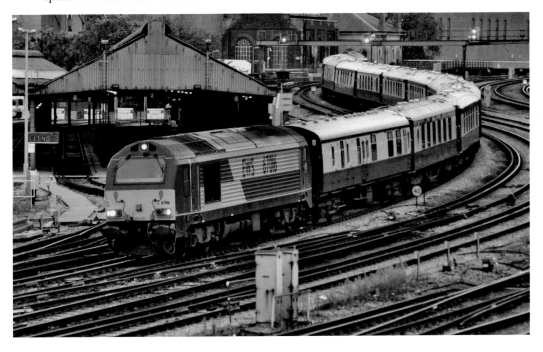

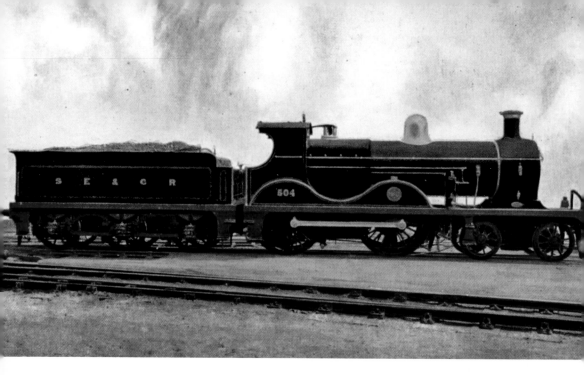

SECR express locos

The SECR was noted for its handsome locomotives with their green liveries and brass domes. Above is No. 504, an E class 4-4-0 designed by the company's engineer H. S. Wainwright and built in 1906 to work first class traffic between Victoria and Dover. It was rebuilt as an E1 class in 1920. These were the successors to Wainwright's successful D class locos, and a fine example of these is on display at the National Railway Museum in York. It is No. 737, built at Ashford in 1901.

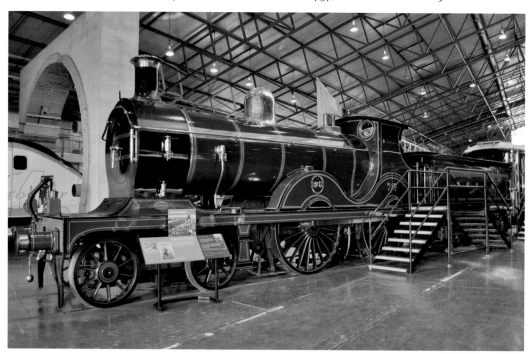

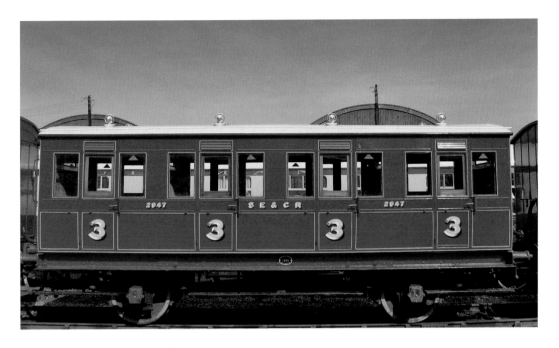

South Eastern and Southeastern

It wasn't all first class travel of course. This is a preserved SECR four-wheeler with four compartments, No. 2947, built at Ashford in 1901 to an LCDR design. It has been preserved by the Kent & East Sussex Railway and was photographed there by Peter Skuce. The South Eastern name is still evident at Victoria Station, albeit amalgamated as Southeastern, which operates around 2,000 train services a day serving the Kent and East Sussex area. No. 375704 is an Electrostar EMU, shown passing under the Eccleston Bridge as it departs from Victoria in October 2010.

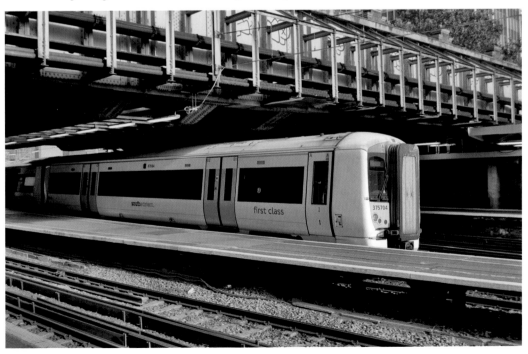

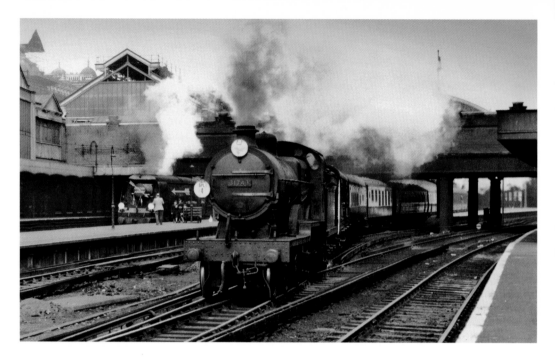

Departures and arrivals

A special train departing from Victoria in 1955, a D1, No. 31743. Note the West Country Pacific class No. 34102 with the Golden Arrow in the background complete with obligatory schoolboys with notebooks at the ready. Below, an early evening Southeastern EMU snakes its way into Victoria Station, photographed from Ebury Bridge. This is one of the busiest times of the day as evident by the empty Grosvenor Road Carriage Sheds in the background.

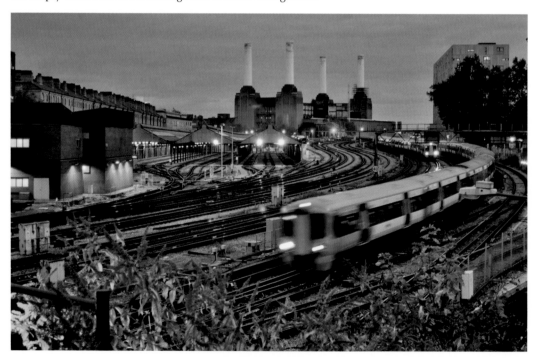

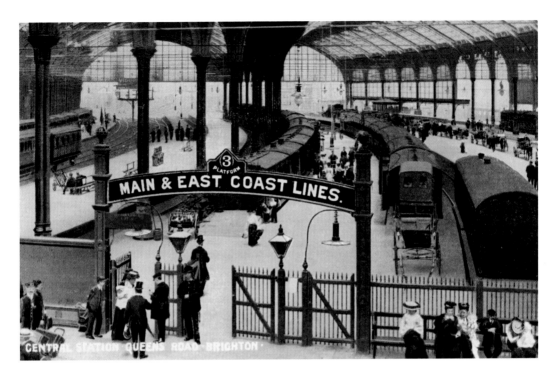

The other end of the line

Brighton passenger station was built by the London & Brighton Railway on a site at the north edge of the town, along with a goods station, loco depot and works. It opened in 1840 and six years later the company became part of the LBSCR. In the 1880s, the original roof was replaced by the fabulous curving double-span iron and glass roof which we see nowadays. (Photo Damon Hart-Davis)

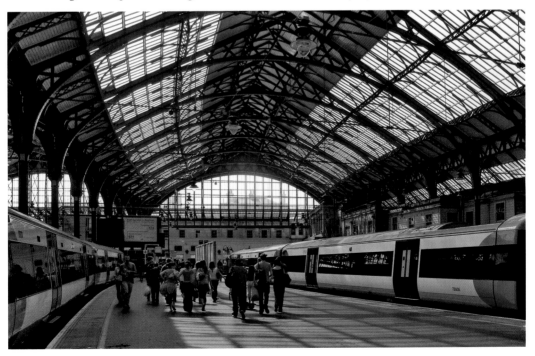

Gateway to the Continent

It may have looked like a prop from a tacky television game show, but the sign above the entrance to Platform 8, 'Golden Arrow – Fleche d'Or', indicated that this was a magic portal, an enticing escape route from the smog and gloom of London to more fashionable destinations. Thanks to its Dover trains the station's ties with Cross-Channel travel go back to the earliest days of the LCDR. 'The shortest express routes to the Continent', proclaimed the hoardings across the station front, and consequently this side of the station became known as the Continental part of Victoria. Like several railway companies the LCDR went on to introduce its own steamships, operating between Dover and Calais, as a natural extension of its services, while the LBSCR, for its part, had the Newhaven-Dieppe crossing. Following the 1923 grouping of the railways into the 'Big Four', the new Southern Railway concentrated its shorter Channel routes through Victoria.

Of all the Continental trains the Golden Arrow is probably the most famous and it was certainly the quickest way to get to Paris, and once there travellers could continue onwards throughout Europe or to the 'Orient'. The Golden Arrow service was inaugurated on 15 May 1929, with trains departing daily from Victoria at 11.00 a.m. to reach Paris by late afternoon. Passengers travelled by Pullman train as far as Dover, where they boarded a cross-channel steamer in the normal manner, and from Calais the French Fleche d'Or completed the journey. The luxurious Pullman carriages in their distinctive brown and cream liveries became the hallmark of the Golden Arrow trains, although by 1932 other non-Pullman carriages were also being included.

The Cross-Channel service reached its zenith in the 1930s when the Southern Railway decided to transport passengers all the way to Paris overnight and without the inconvenience of leaving the train at all. As an article in the company's quarterly magazine reported; 'You can now go to Victoria Station just before 10.00 p.m., get into your sleeping car there; stay put in it; and get out at the Gare du Nord, Paris, at 8.55 a.m. next morning. Conversely, you can go to bed in your Paris sleeper at 9.50 p.m. (dog-weary as usual!) and reach Victoria, undisturbed, at 8.30 next morning. Which, to say the least of it, is a feat of no mean order.' And that was no understatement for the Night Ferry operation had involved the construction of three special ferries, SS *Hampton*, *Twickenham* and *Shepperton*, twelve purpose-built sleeping cars, plus the creation of a new jetty and sea locks at Dover Harbour to keep the ferries level with the rails during loading.

The Night Ferry train generally operated from Platform 2, and its dark blue coaches were the only direct link to Paris from the start of the

service on 5 October 1936 until the Eurostar began running through the Channel Tunnel in 1994. The sort of passengers who used it were very much of the 'smart set' and many remained loyal to the service long after the introduction of regular flights to the Continent. Yehuidi Menuhin was said to be a regular, as were the Duke and Duchess of Windsor travelling between London and their home in Paris.

Various other members of the Royal Family and visiting dignitaries have also passed through the station over the years thanks to its close proximity to Buckingham Palace. Victoria Station became the departure point for thousands of troops on their way to the trenches of France and Belgium during the First World War. It was also here that many of the wounded and soldiers on leave would arrive back in 'Blighty'. During the Second World War, the Nazi occupation of France brought an abrupt halt to the Cross-Channel services, and it wasn't until April 1946 that the Golden Arrow returned, this time with an all-Pullman service, although it was December 1947 before the Night Ferry trains restarted.

Platform 8 at Victoria, from which the Golden Arrow started its journey to Paris. Passengers had to disembark from the train at Dover and take the ferry to Calais. After the introduction of the Night Ferry in 1936 they could actually stay in bed all the way to Paris.

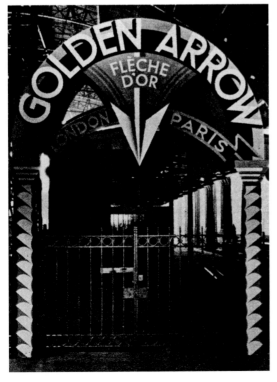

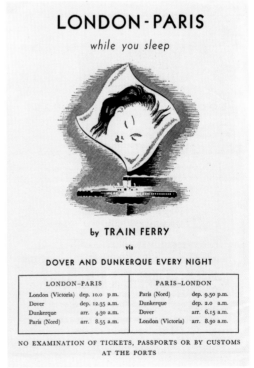

LONDON - PARIS

while you sleep

by TRAIN FERRY

via

DOVER AND DUNKERQUE EVERY NIGHT

LONDON–PARIS		PARIS–LONDON	
London (Victoria)	dep. 10.0 p.m.	Paris (Nord)	dep. 9.50 p.m.
Dover	dep. 12.35 a.m.	Dunkerque	dep. 2.0 a.m.
Dunkerque	arr. 4.30 a.m.	Dover	arr. 6.15 a.m.
Paris (Nord)	arr. 8.55 a.m.	London (Victoria)	arr. 8.30 a.m.

NO EXAMINATION OF TICKETS, PASSPORTS OR BY CUSTOMS
AT THE PORTS

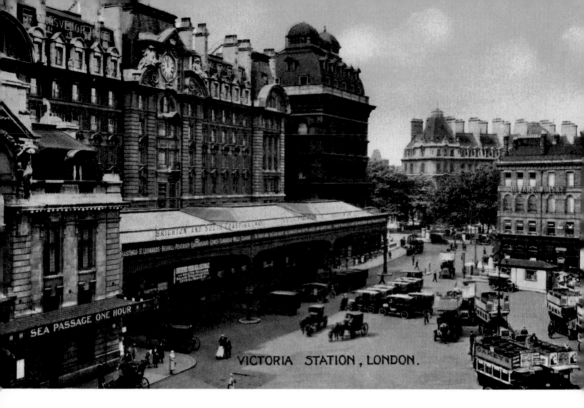

VICTORIA STATION, LONDON.

Continental rivals

While the frontage of the LBSCR's station towered above its eastern neighbour, it was the LCDR station, or rather the SECR's after 1899, that became known as the 'Gateway to the Continent' or the more fashionable 'Continental side' of Victoria. In this postcard from *c.* 1920 the SECR's sign proclaiming, 'Sea Passage One Hour', can be seen on the left.

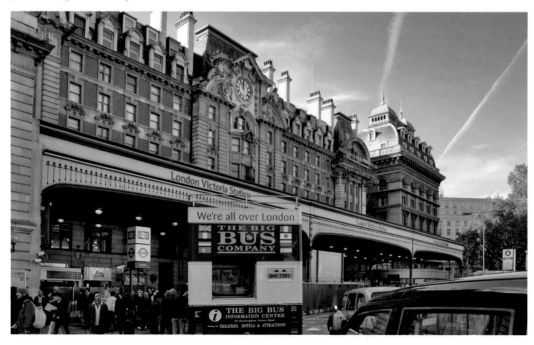

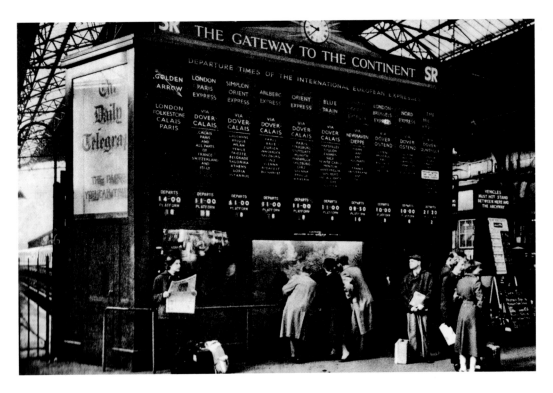

Destination and connections

At the height of the international service in the 1930s Southern Railway's famous departure board for European Expresses reads like an atlas of Europe with destinations via Dover and Folkestone to Paris, Lausanne, Milan, Venice, Belgrade, Salonika, Athens, Zurich, Salzburg, Vienna, Budapest, Stuttgart, Munich, Monte Carlo and Brussels. Today's electronic destination board on the eastern side of Victoria Station lacks the foreign connections, not to mention the charm of the old one.

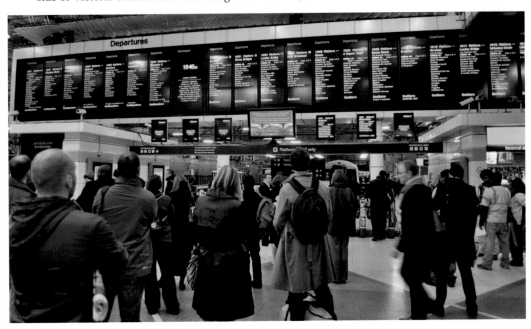

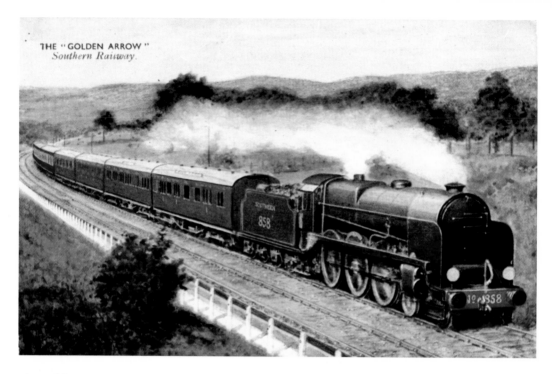

THE "GOLDEN ARROW"
Southern Railway.

The Golden Arrow

Southern Railway's iconic express connection between Victoria and the ferries at Dover, a pre-war Golden Arrow pulled by *Lord Duncan*. This was one of sixteen Lord Nelson or LN class 4-6-0 locomotives designed by Richard Maunsell and built at Eastleigh. *Lord Duncan* was constructed in 1929 and withdrawn by British Railways in 1961. Travellers enjoyed armchair comfort riding in the Pullman coaches on the 1930s Golden Arrow.

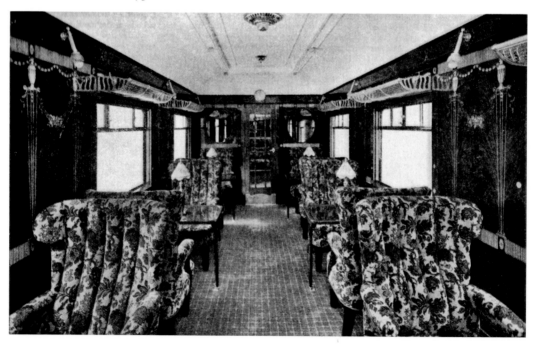

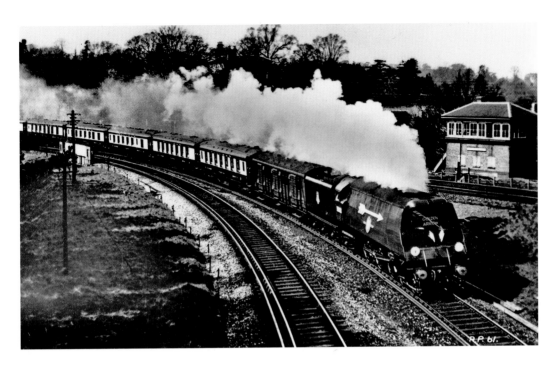

Merchant Navy and Battle of Britain class

Designed by Oliver Bullied the square fronts of the Merchant Navy and Battle of Britain class locomotives became a distinctive feature of the post-war Golden Arrow trains. Shown above is No. 35028 *Clan Line*, a 4-6-2 air-smoothed locomotive of the 21C1 or Merchant Navy class, although these were sometimes known informally as the Bullied Pacifics. At the National Railway Museum you can see No. 34051 *Winston Churchill*, an example of the lighter weight Battle of Britain design.

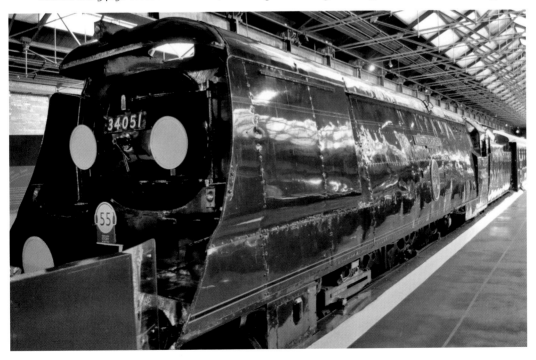

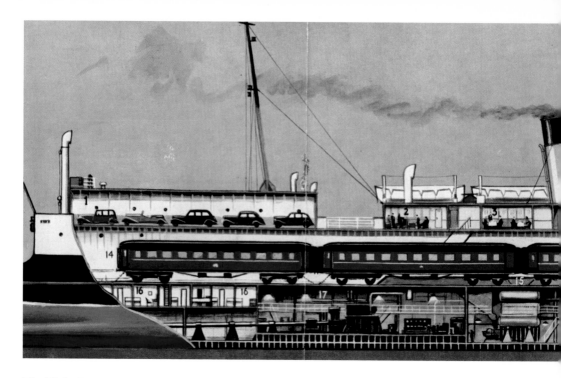

The Night Ferry

Published by Southern Railway's in 1936, this cutaway shows the distinctive blue coaches loaded on board *Twickenham Ferry*, one of three special steamers built by Swan Hunter in Newcastle. On the top deck was a garage for twenty-five cars plus saloon for normal ferry users, then came the train deck for eight railway coaches known as 'Wagon-Lits' or sleeping coaches. One of these is now displayed at the National Railway Museum.

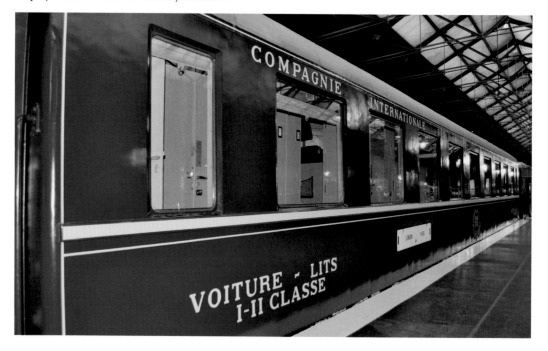

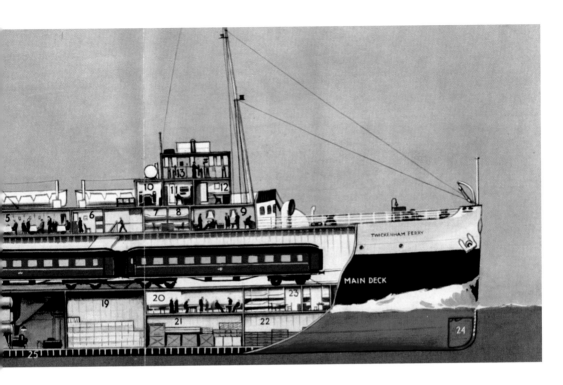

Night and day

During the daytime the steamers would return across the channel to their respective ports with freight wagons instead of the sleeper cars. Apart from the inevitable gap during the war years, the Night Ferry operated from 5 October 1936 until 31 October 1980. An attempt to revive the service in the 1990s was abandoned when the Channel Tunnel opened in 1994.

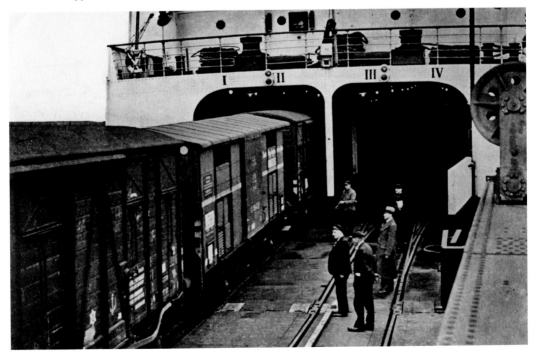

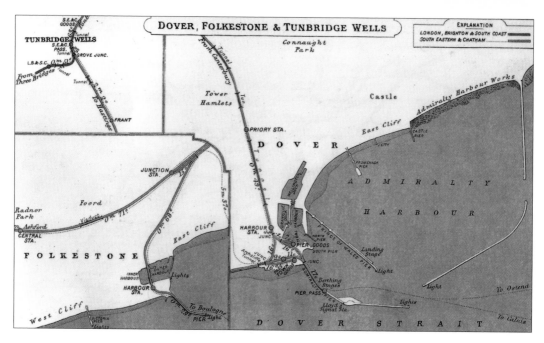

Dover Marine Station

A diagram of the lines around Dover, Folkestone and Tunbridge Wells. In 1936, a special sea lock was created at Dover for the loading and unloading of the Night Ferry trains. Golden Arrow passengers would alight at Dover Marine, renamed Dover Western Docks in 1979, which was finally decommissioned in 1995. The arrival of the 'Continental Farewell' rail tour from Victoria was photographed by Andy Veitch in 1994.

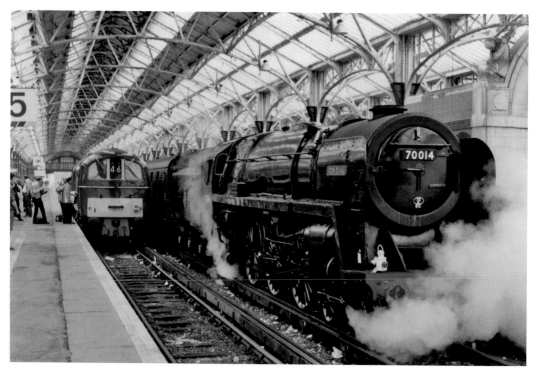

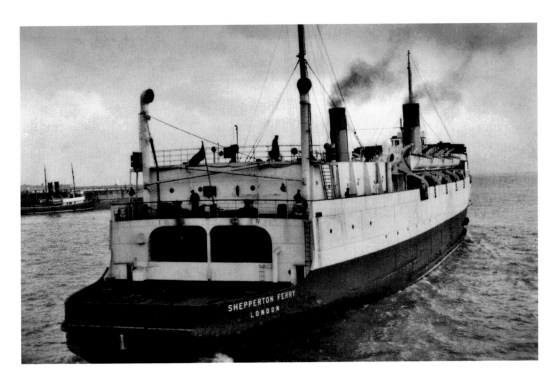

Shepperton Ferry

The *Shepperton Ferry* departing from Dover. In 1963, the ship was repainted in British Railway's livery with the infamous 'double-arrows of indecision' logo, and again in 1969 in Sealink colours. She was finally scrapped in 1972. The French terminal for both the Night Ferry and Golden Arrow services was the Gare du Nord in Paris, with a midday departure in the 1930s shown here.

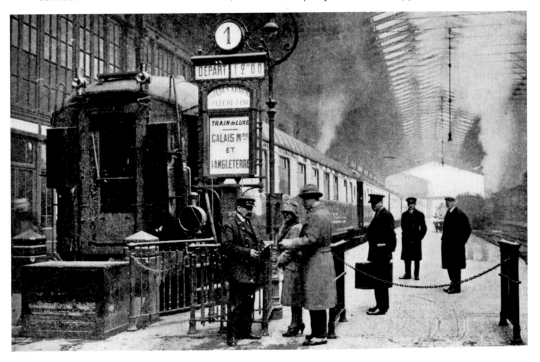

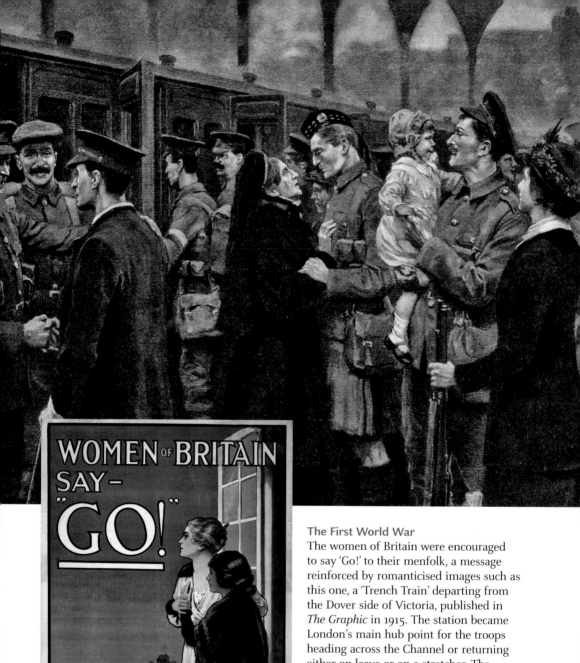

WOMEN OF BRITAIN
SAY —
"GO!"

The First World War

The women of Britain were encouraged to say 'Go!' to their menfolk, a message reinforced by romanticised images such as this one, a 'Trench Train' departing from the Dover side of Victoria, published in *The Graphic* in 1915. The station became London's main hub point for the troops heading across the Channel or returning either on leave or on a stretcher. The photograph on the opposite page shows soldiers heading back to the fighting after Christmas leave in 1916; 'In the true British way, there was not much show of emotion.' In November 1920, Victoria Station received the body of the unknown warrior on its way to Westminster Abbey. Still commercial rivals until 1923, each station has its own plaque to commemorate railway staff who died in the conflict.

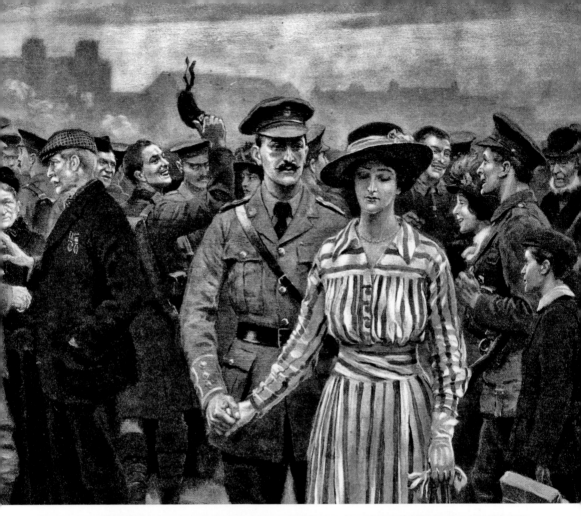

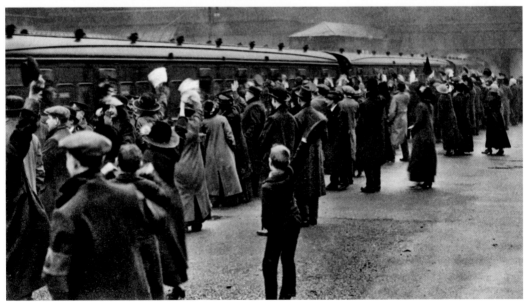

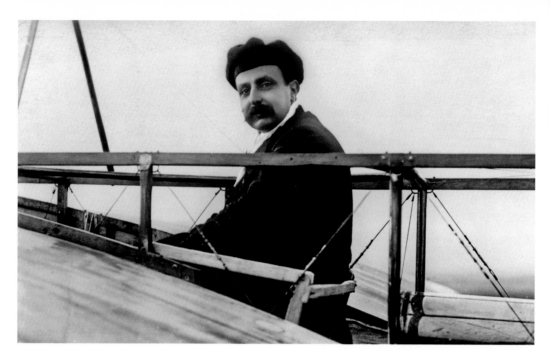

Famous arrivals at Victoria

Because of the Channel port connections, Victoria Station has seen many celebrity arrivals and departures over the years. Most notably the French aviator Louis Blériot who was enthusiastically greeted upon his arrival in London following his historic cross-Channel flight from France in 1909. (Photo Library of Congress)

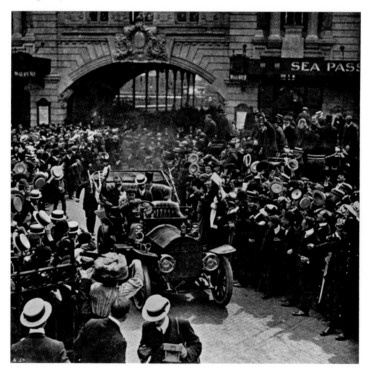

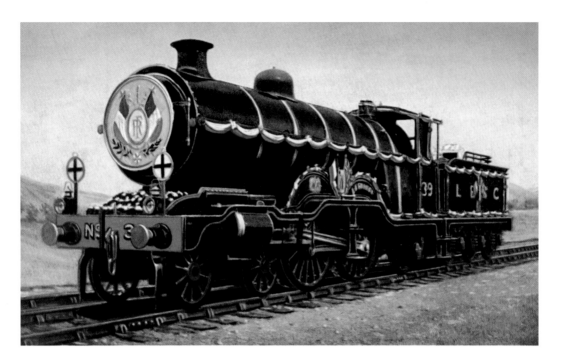

Royalty and heads of state

The LBSCR locomotive No. 39, an H1 class 4-4-2, was christened as *La France* and specially decorated in 1913 prior to the visit of the French President. The company was not known for naming its locomotives, but this name stuck until 1926 when the Southern Railway changed it to *Hartland Point*. The NRM at York houses the Stroudley-designed B1 class *Gladstone*, wearing the royal coat-of-arms on front and sides, plus 'ER' monogram, presumably for King Edward VII.

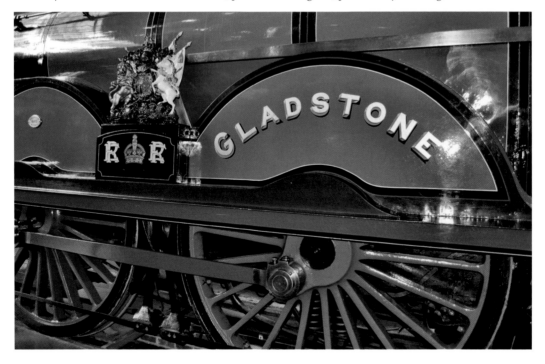

Transport Connections

It was inevitable that London's major railway termini became hubs for other forms of transport within the city. The underground railway reached Victoria quite early on, in December 1868, when the Metropolitan District Railway opened a station on the north side of Terminus Place. This was on the first section of the line between Westminster westwards to South Kensington where it connected with the Metropolitan Railway. Although these two companies were rivals they operated over each other's tracks on what was known as the Inner Circle. Today, Victoria has become the busiest of the underground stations in the capital and serves the Circle and District lines, plus the Victoria Line itself. This became the first new tube line to be built under central London for sixty years when it opened in March 1969. Currently there are plans to link Victoria with the proposed Crossrail 2 Chelsea-Hackney line, and possibly with the Docklands Light Railway at some time. To cope with the steady increase in passenger numbers using Victoria Underground station, already estimated at nearly eighty million a year, a major upgrade of the facilities has been initiated – *see Evolution section*.

On the surface, Victoria has its own bus station, although at first glance this seems an over-blown term for the gathering of red buses that cluster into or around the former station yard, but don't be fooled. Victoria is London's busiest bus station with 200 buses per hour at peak times, made up of nineteen bus services either terminating here or passing through. Just a hefty stone's throw across Buckingham Palace Road, to the south-west of the railway station, is Victoria Coach Station which happens to be London's major terminus for long distance coaches. Designed by architects Wallis, Gilbert and Partners,

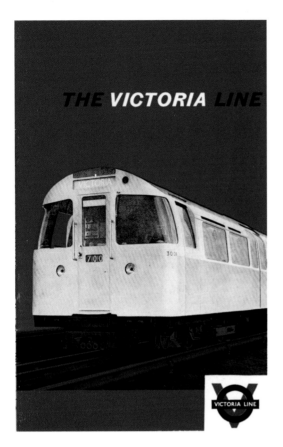

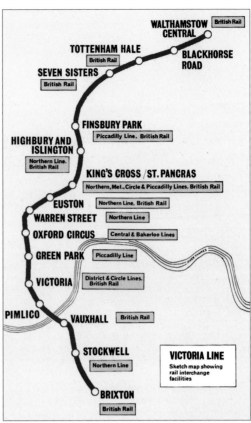

The first stage of the Victoria Line, designed to provide a new north-side link across London and the Thames, was opened in 1969. Eventually the line ran from Walthamstow in the north down to Brixton in the south. Note the special Victoria Line 'V' logo on the cover of this 1960s booklet.

and opened in 1932, this is a magnificent example of Art Deco styling with its clean geometric lines and chunky tower.

If the coach station represented the growing competition faced by the railways from road transport, then the arrival of another Art Deco tower rising up on the other side of Buckingham Palace Road pointed in an entirely new direction. The Imperial Airways building is a fantastically bold statement of corporate confidence in the future of air travel. Designed by Albert Lakeman, its clock tower of gleaming Portland stone dominates the skyline and at its base the 'Speed of Wings' sculpture sits centrally above a curving frontage. This was the Imperial Airways Terminal, no less, and for good reason as air passengers could check-in and then pass through to a special platform at the rear of the building to catch a direct train to the flying boat terminal at Southampton docks. The flying boats have long gone, but every day thousands of air travellers still take the Gatwick Express from Victoria.

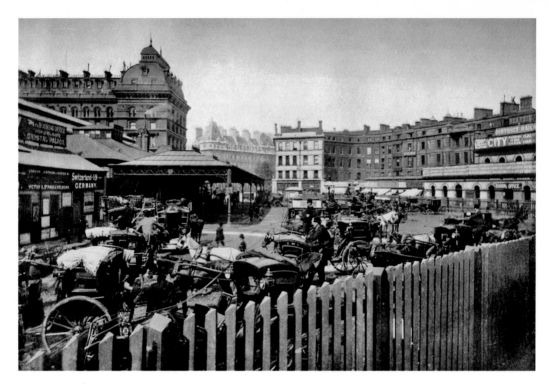

From station yard to bus station

The triangle of land that formed the station yard was the gathering point for the many horse-drawn cabs and coaches in the 1890s. Today, the Victoria Bus Station is London's busiest with 200 buses passing through every hour at peak times. The yard has become Terminus Place, although many of the buses also stop on Buckingham Palace Road. (TfL photo)

Victoria Underground Station

The Underground station was opened in December 1868 by the Metropolitan District Railway. Today it serves the Circle Line, District Line and the Victoria Line with a staggering eighty million passengers passing through every year, making it the busiest tube station in the capital. As can be seen from the London Transport Museum (TfL) photo of 1957 the façade and entrances off Terminus Place still remain.

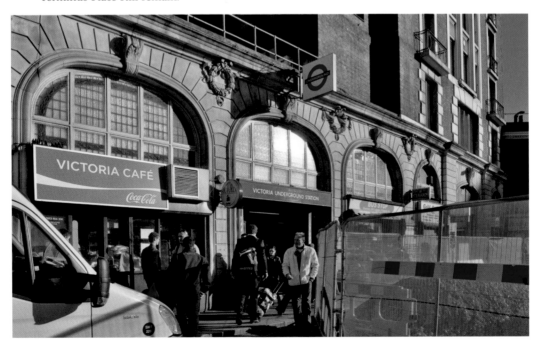

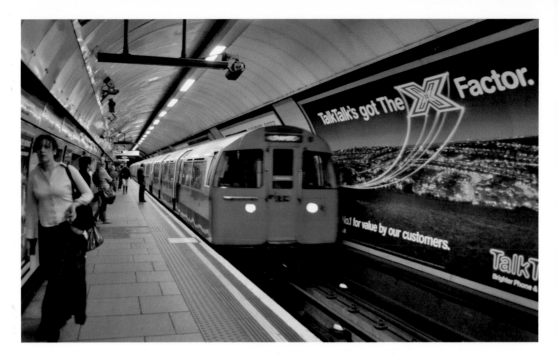

Old and new Underground stock
The original 1967 'A' stock is still be seen on the Victoria Line, contrasting with the new stock shown at Euston tube station on the opposite page. This design was introduced in July 2009 as part of a £3.4 billion contract which will see the older trains phased out by 2012. Interior photograph of a refurbished a 1967 carriage by Peter Skuce.

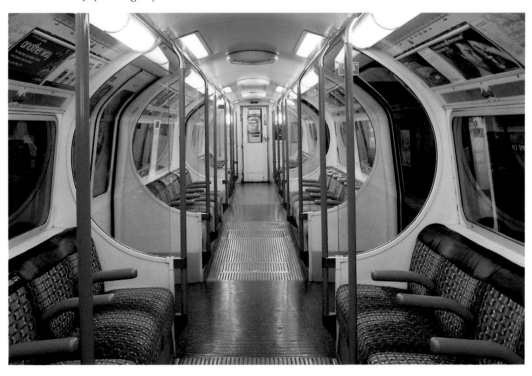

And the next station is ...

As the stations on the Victoria Line all look so similar, a series of colourful motifs was introduced to provide visual clues to help travellers recognise their location. These take the form of recessed panels above wooden benches, and are created in ceramic tiles. While the design for Victoria is simple enough, a profile of the young queen, others are a little more esoteric. *See the next page.*

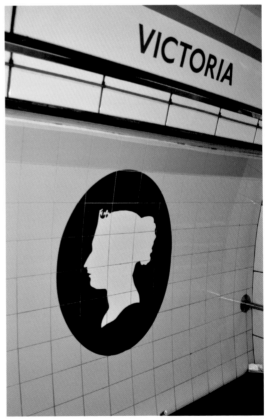

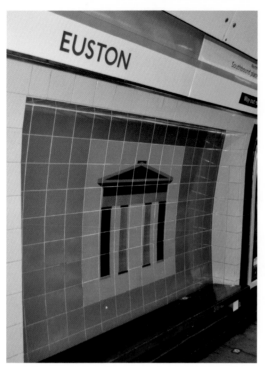
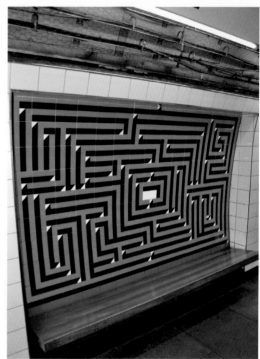

Confusing the tourists

Euston Station on the Victoria Line is represented by a motif of the famous Doric archway demolished back in the 1960s. Warren Street, situated between Oxford Circus and Euston, has a maze design in black and red, while Stockwell's motif is this swan, which represents a nearby pub.

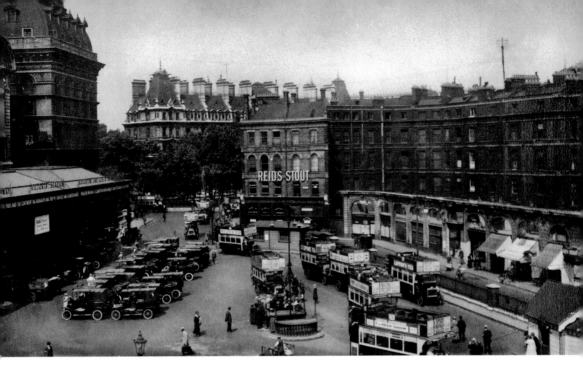

Buses and taxis in Terminus Place

A superb view of the triangle of land on the north side of Victoria Station, taken around 1925. Still fenced off from the road, the station yard is packed with motorised taxis and buses and there is not a single horse-drawn vehicle to be seen. The entrance to the Underground is on the right and this station was linked by pedestrian subway to the mainline station on the left. By 2008, the scene hadn't changed that much except perhaps for the Victorian building on the far side of Buckingham Palace Road, which has been replaced, as shown in this photograph by Arriva436.

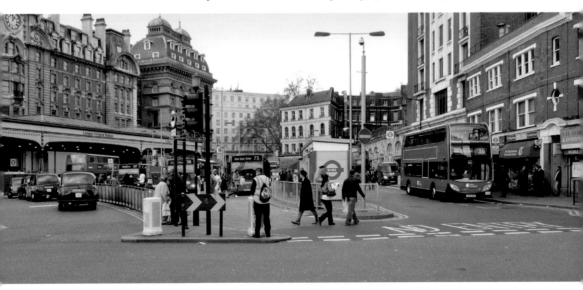

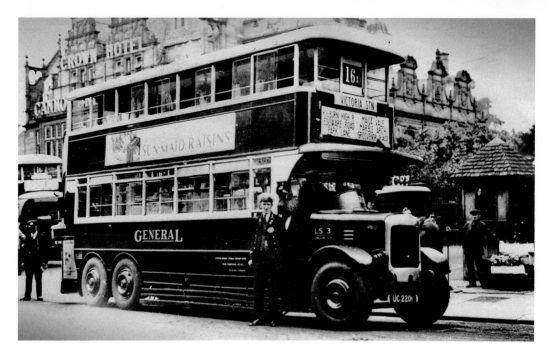

Seeing red

London's buses started turning red over 100 years ago when the London General Omnibus Company (LGOC) adopted the colour for its vehicles in 1907. One of its six-wheelers, No. LS3, is shown above on its way to Victoria Station. By 1933, LGOC had become part of London Transport. The latest six-wheeled vehicle is the controversial Mercedes Benz Citaro articulated bus, otherwise known with varying degrees of affection as the 'bendy bus' and introduced in 2002 by the then Mayor of London Ken Livingstone. (Photo Arriva436)

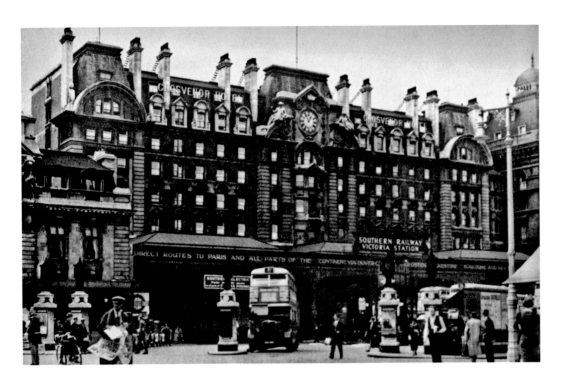

Victoria Bus Station

The vehicles might have changed but the sight of London's red buses coming and going outside Victoria Station is largely unaltered. In the upper photograph, from the late 1950s, the station yard area is still marked by stone gate posts before it became amalgamated with Terminus Place. At one time, London Transport introduced protective canopies above the bus lanes, but these were removed in 2003 as part of on-going refurbishments and to open up the view of the station frontage.

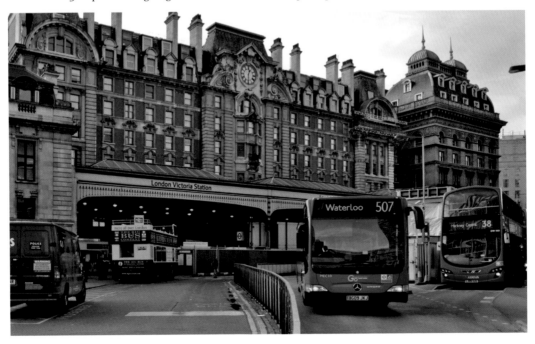

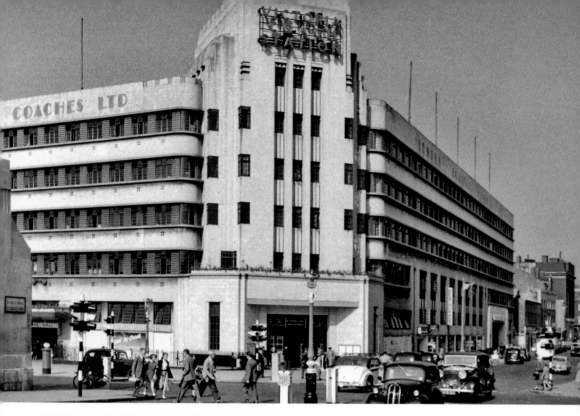

Victoria Coach Station

One of London's iconic 1930s buildings, the Coach Station on Buckingham Palace Road was designed by architects Wallis, Gilbert & Partners for London Coastal Coaches in 1932. It is a fantastic example of the Art Deco style with its strong use of horizontal lines, curved edges and central block-shaped tower. It has changed little since Allan Hailstone photographed it in 1955, although an additional storey has been discreetly added on the roof. Note the nicely detailed windows on the corners of the tower. It was extensively renovated in the 1990s and is a fine companion to the Imperial Airways building across the road (shown opposite). Ownership of Victoria Coach Station has changed many times over the years; most recently it was transferred to London Transport in 1988 and then passed to Transport for London in 2000.

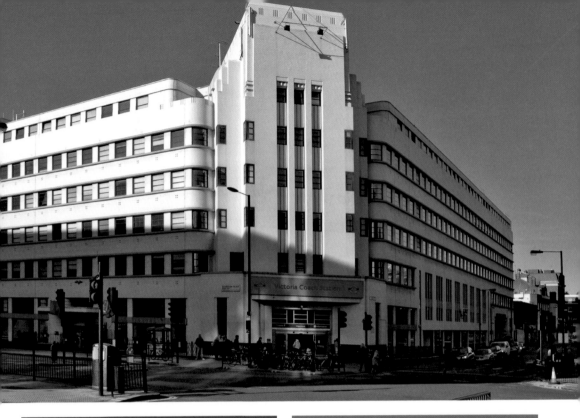

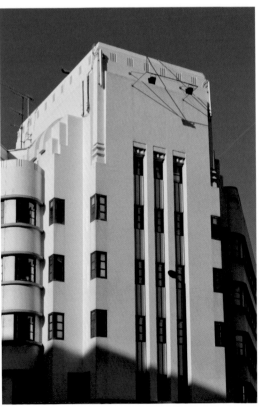

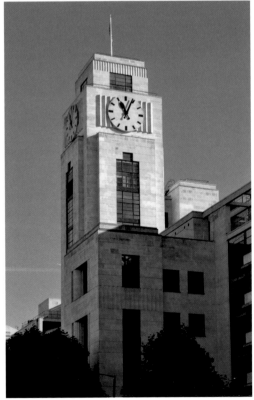

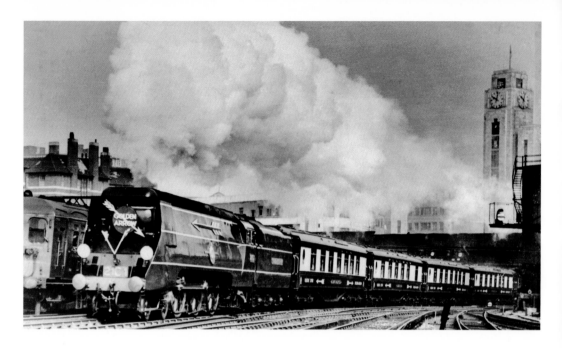

The world's first direct rail-air link
This 1952 image of the Golden Arrow departing from Victoria features the tall clock tower of the Imperial Airways Terminus in the background. Designed by Albert Lakeman in 1939, on the rail-side the building had its own independent platform from which passengers travelled to Southampton Docks to connect with the company's flying boat services. In the lower image, taken from Ebury Bridge, the tower is still stands out although surrounded on either side by later buildings. The rails wind past the signal box and disappear under Elizabeth Bridge and beneath the Victoria Place shopping complex. *See also, page 71.*

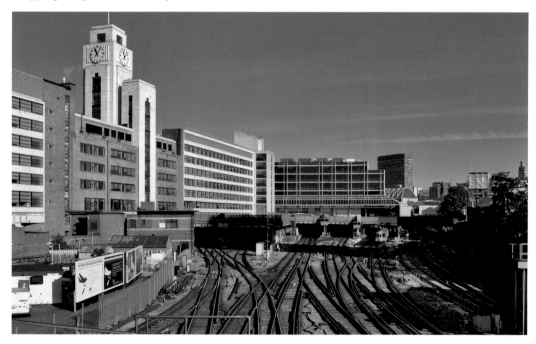

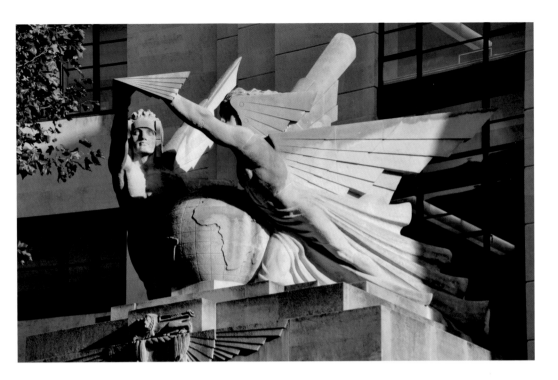

Imperial Airways Terminal building

On Buckingham Palace Road the former Imperial Airways building describes a gentle curve of silver Portland stone with the clock tower rising at its centre. At its base is a magnificent sculpture, Speed Wings Over the World, by Eric Broadbent. This is the architectural equivalent of a car radiator mascot, a Spirit of Ecstasy in stone, and closely echoes Imperial Airway's wing logo. As the building is now occupied by the National Audit Office, many a visitor must puzzle as to its significance.

63

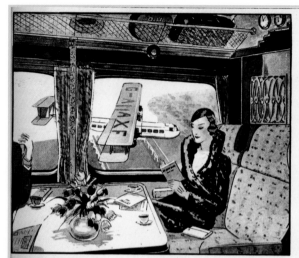

The luxury that is not expensive
IMPERIAL AIR TRAVEL

The speed and luxury of travel by Imperial Airways will be a revelation to you. London to Paris in a 2¼ hours flight. To India in 7 days. To Cape Town in 11 days. In both the above Empire journeys you will sleep comfortably on land each night in accommodation provided free by Imperial Airways. There is lavatory accommodation in every Imperial Airways liner. You can book to intermediate places en route and the journey itself will be of extraordinary interest, while the time saved is of immense value. Excellent meals are served on board during flight

FOR YOUR SUMMER HOLIDAYS

Switzerland in half a day by air! Leave the Air Port of London, Croydon, 8·30 a.m., arrive Basle 2 p.m. There are special reduced 15 day return fares! Ask your travel agent for information

FULL DETAILS and leaflets about the routes from any travel agency or from Imperial Airways Ltd., Airway Terminus, Victoria Station (facing entrance to Continental Departure platform), S W 1
Telephone : Victoria 2211 (Night and Day) Telegrams : 'Impairlim, London'

ALSO SEND YOUR MAILS AND FREIGHT BY AIR

IMPERIAL AIRWAYS

LONDON : Airway Terminus, Victoria Station (Continental Departure), S W 1 ; PARIS : Airways House, 38 Avenue de l'Opéra ; ALEXANDRIA : Marine Air Port, Ras-el-Tin. P.O. Box 1705 ;

A new way to travel

This looks like an advertisement for luxury trains at first glance, but in fact it is for Imperial Airway flights to Paris. This service was inaugurated in 1924 from Croydon Aerodrome, London's official airport at the time, using four-engined Handley Page biplanes.

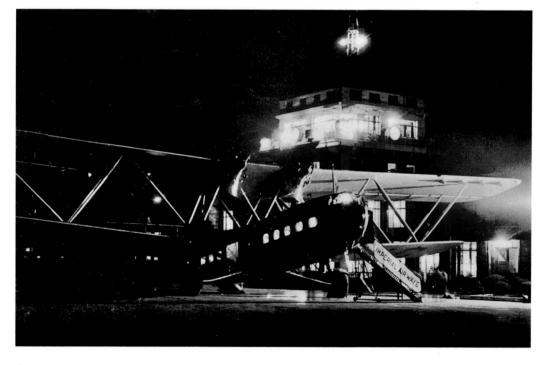

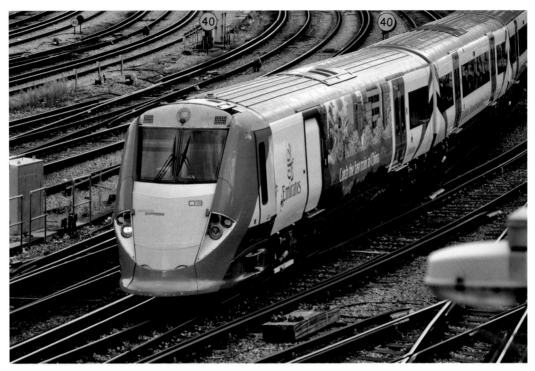

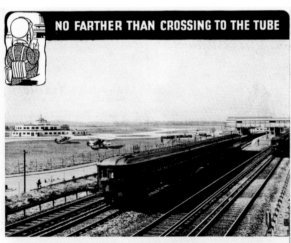

The Gatwick Express

Scheduled flights from Gatwick Airport began in May 1936 and the airport's first station, to the south of the present one, was connected to the innovative 'Beehive' terminal building by subway. The new Gatwick Airport station was opened in 1958 and, as before, this was served by London–Brighton stopping trains. Surprisingly, a dedicated non-stop Gatwick Express service did not start until 1984, with trains originally made up of Class 73 locomotives and Mk2 coaching stock. In 1996, the franchise was awarded to the National Express Group and the entire fleet was replaced with eight of the Class 460 'Juniper' EMUs dedicated to the twenty-seven mile Victoria Gatwick run. The Southern franchise took over in 2008 and some services have been extended to Brighton. A number of Class 442 'Wessex Electrics' also entered service in December 2008.

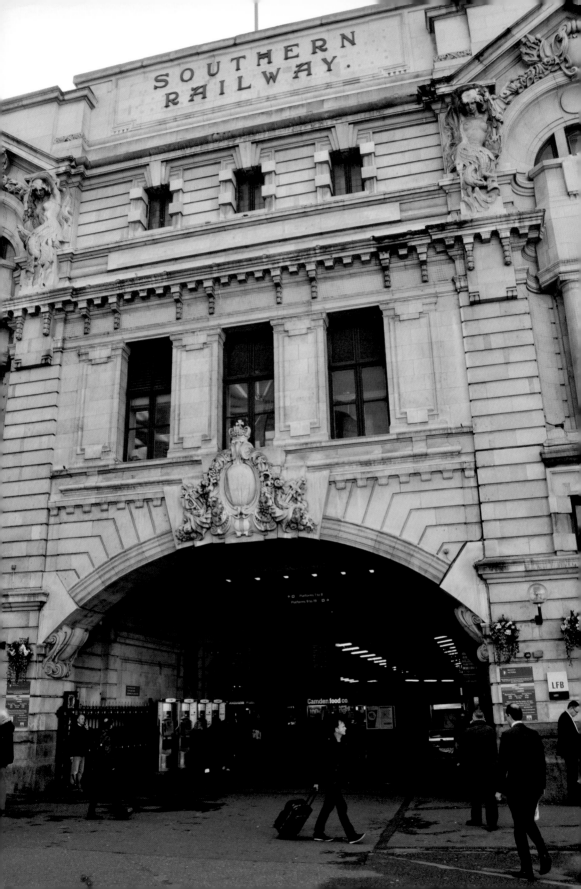

Evolution

Major railway stations change and evolve with time. It is a natural process, usually in response to the changing demands of the railway users, in particular an increase in passenger numbers, although sometimes it is driven by external political or commercial factors. For Victoria Station the twentieth century had started with the rebuilding of the LBSCR station on the Brighton side and the new frontage for the LCDR's side, although by 1899, the LCDR had formed a common management committee with the South Eastern Railway and became known as the South Eastern & Chatham Railway (SECR).

The biggest shake-up for Britain's railways came in 1923 when the 120 or so individual companies were grouped into the 'Big Four' – the GWR, LNER, LMS and SR. During the First World War, the railways had been under government control and this had proved beneficial in many ways, not least in cutting out the wasteful duplication of services by rival companies. At Victoria, the years of rivalry were put aside and the two stations became one under the control of the newly formed Southern Railway. This union was marked by the opening of two brick arches in the dividing wall and the renumbering of the platforms right across the station, starting from Platform 1 on the east side to Platform 17 which runs parallel to Buckingham Palace Road. These are the same platform numbers that we still have today.

On the operational side, the Southern Railway continued with various improvement programmes, including electrification, which had been initiated by the old companies. Electric traction had first appeared at the LBSCR station in 1906 with an overhead system, although this was later abolished when Southern Railway changed to a third-rail direct-current system from 1929. Electrification of the Brighton line was completed by 1933, while on the eastern side it was a slower process and the lines to Dover and Thanet were not fully electrified until 1959. Electricity was also playing its part in replacing the old system of manually operated signals and points. The SECR completed a re-signalling scheme for its tracks by 1920 and this included a new signal cabin just beyond Platform 1. On the other side of the tracks, a large brick-built signal box was erected in 1939 with electrically powered frames for coloured light operation.

During the Second World War, the Luftwaffe did its best to re-model Victoria, most notably achieved in 1944 when a V1 Doodlebug struck the station. By the end of the war, the railways were left bruised and battered, and in January 1948, the Labour government nationalised the entire network as British Railways, which remained under the control of the British Transport Commission. In those post-war years people were hungry for change and a new spirit of optimism was given expression in

the 1951 Festival of Britain held on London's South Bank. Symbolically, this saw a derelict bomb-damaged site swept away by a bright vision of the future, a fanfare of progress with buildings shaped like flying saucers and a needle-sharp pylon that pierced the sky. Concrete and steel were the order of the day, and London's ageing railway stations were looking decidedly shabby and out of favour.

On the practical side they still had to function efficiently and cope with ever increasing demand. Because Victoria's site is severely restricted, by the buildings on Buckingham Palace Road on one side and by the houses of Belgravia on the other, there was little scope to increase its width in order to create more platforms. Instead Platforms 1–8 were lengthened in 1960 to accommodate the longer electric trains of twelve or fourteen coaches – requiring the reconstruction of Eccleston Bridge to create extra space for the platforms – and changing the complicated track layout almost as far as the Thames. This permitted the re-slewing of the tracks serving the extended platforms, plus new cross-over points between the east and west sides. Over the river itself the Grosvenor Bridge was extensively rebuilt in steel, with the original piers being encased in concrete.

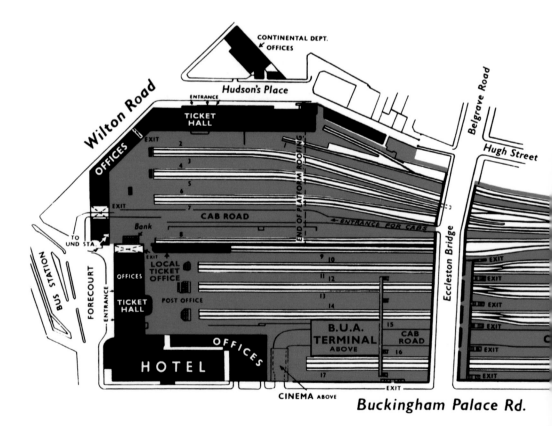

The same fate could so easily have befallen Victoria station itself. There were calls for the entire station to be swept away during the 1950s and 1960s. That it has survived at all seems down to sheer good luck. But Victoria has not escaped unscathed in the ensuing years and the piecemeal encroachment of commercial development has left this old friend inexorably scarred. 1963 was a significant year with the end of steam at Victoria and the appearance of a concrete slab built across the end of Platforms 15–17 to support a new eight-storey office block. In 1980, plans were unveiled for a major 'reconstruction' of the terminus. The south train shed was demolished to be replaced by a 'raft' of concrete supporting a shopping centre and offices. The result, claimed one critic, made the place feel like a multi-storey car park.

With the demise of British Rail, Victoria passed into the ownership of Railtrack in 1994 and they announced a £250 million redevelopment scheme in 2001. That fell by the wayside when Railtrack was superseded by Network Rail in 2005. At the time of writing the station is a hive of activity as the old SECR roof undergoes a £24 million renewal and, outside, work has commenced on a £509 million upgrade of the Underground station.

Station plan c. 1970
This British Rail plan of the station, drawn before the modern building over the south train shed, is packed with information. North is towards the bottom left with the Dover side of the station at the top and the Brighton side at the bottom. In particular note the cab roads, one coming off Eccleston Bridge and the other off Buckingham Palace Road and leading up to Elizabeth Bridge. The Imperial Airways Terminal has become the BOAC Terminal and encroaches above the tracks, while a British United Airways Terminal is shown above Platforms 15–16.

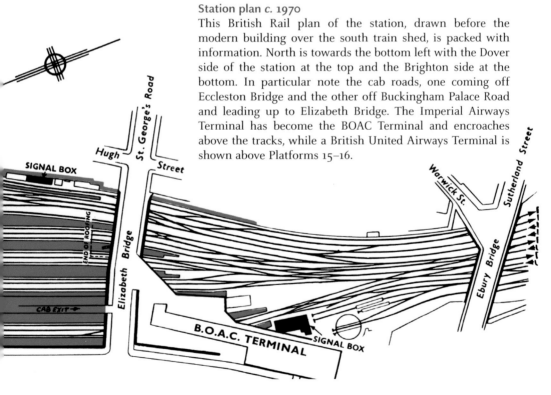

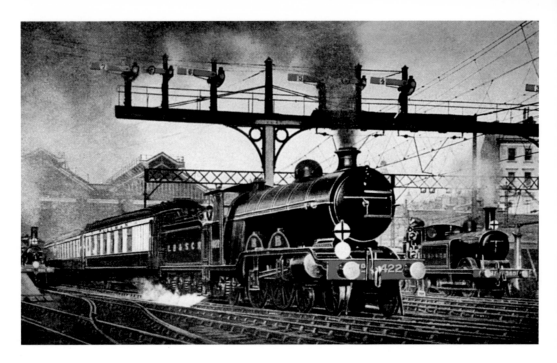

Signals and departures

Two views of the semaphore signal gantry between Eccleston and Elizabeth Bridge. Locomotive No. 422, shown above, is an LBSCR Marsh Atlantic 4-4-2 heading the Southern Belle Pullman train out of Victoria in 1921. In the post-grouping image, below, No. 198 is another old LBSCR loco, this time a Stroudley Class B 0-4-2, built at the Brighton Works in 1888 and serving out its days for the Southern Railway before retirement in 1930

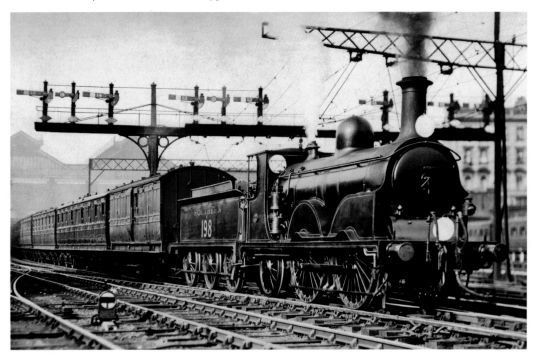

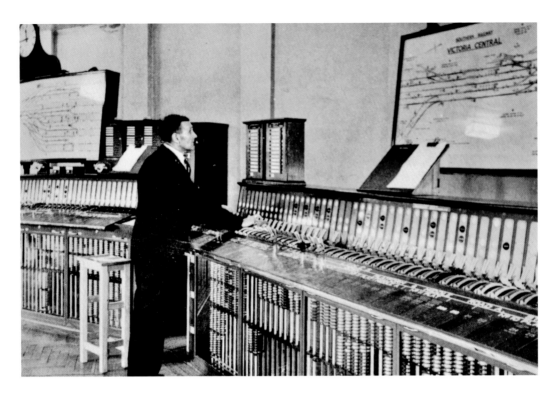

Signal Box

The epitome of modern signalling in the 1930s, the signal box is fitted with the latest all-electric miniature lever frames beneath a circuit diagram for Victoria Central. Located on the western side of the rails beside the old Imperial Airways/BOAC Terminal, it can be seen from passing trains as in this 2008 photograph by Damon Hart-Davis. *See page 62.*

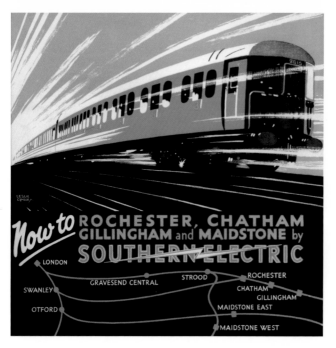

Southern electric
In this advertisement from *The Railway Gazette* of June 1939, Southern Railway announced that electrification of the line had been extended on the south-east routes. Electrification had first appeared at Victoria in 1906 with an overhead system on the Brighton side, but Southern changed to the third rail system and electrification of the Brighton line was completed by 1933.

Battered and bruised, members of the British Expeditionary Force head towards London on a Southern Railway train after being rescued from the beaches of Dunkirk in the spring of 1940. In particular note the rail-side warning sign, 'Southern Rly – Danger – Don't Touch Conductor Rail.'

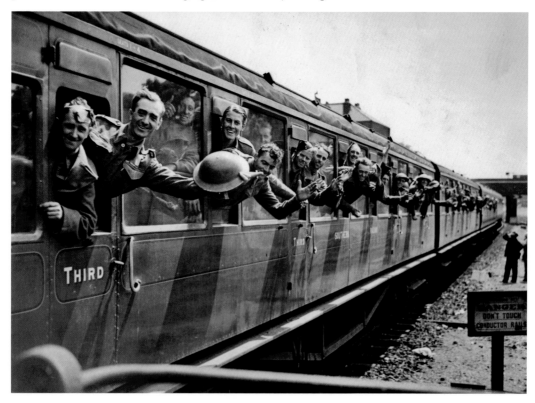

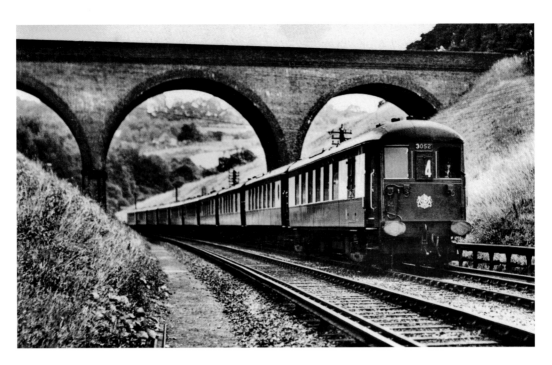

An electrified Brighton Belle

Southern Railway introduced three of these five-car Pullman electrical multiple units (EMUs), designated as 5BELs, in 1933. The following year, the Southern Belle service from Victoria to Brighton was renamed as the Brighton Belle. It was the first electric all-Pullman service in the world. The Brighton Belle was withdrawn from service in 1972 and two of the Driving Cars, 88 and 91, are being preserved by the 5BEL Trust and are shown here during restoration. There are ambitious plans to revive the service in time for the 2012 Olympics. (5BEL Trust)

BATTLE OF BRITAIN CLASS LOCOMOTIVE

Introduced in 1946 by the then Southern Railway, these three-cylinder locomotives are smaller editions of the famous Merchant Navy class. They were all named after people, squadrons, aerodromes, etc., connected with the Battle of Britain in the last war. We show *Fighter Pilot*, as she was built in 1947. Under British Railways, her number is now 34055. The number 21C155, under Southern Railway notation, meant: C for the number of driving axles, three for the third letter of the alphabet; the first figure, 2, for leading bogie axles; the second figure, 1, for the trailing axle - in other words, a Pacific wheel arrangement. The number after the capital letter was that of the engine in the class. The Battle of Britain class are fitted with the unique Bulleid chain-drive valve gear, instead of the conventional Walschaerts valve gear. Weight of engine and tender in working order, 128 tons 12 cwt.

KEY TO NUMBERED PARTS

(1) Inner fire-box and brick arch. (2) Water from boiler siphon circulates through fire-box. (3) Water level over fire-box. (4) Driver's regulator and steam entry valve. (5) Safety valves. (6) Steam pipe to superheater. (7) Superheater header. Steam passes back into boiler, through flues, and returns superheated. (8) Superheater boiler flues. (9) Fire-tubes. (10) Superheated steam pipe to outside cylinder. (11) Superheated steam pipe to inside cylinder (12) Bulleid patent piston valves and rocker arm. (13) Piston. This would be on the backward stroke if the locomotive was moving forward. (14) Outside cylinder exhaust to blast-pipe. (15) Exhaust blast-pipe for all three cylinders. (16) Chimney bell. (17) Inside cylinder valve-chest. (18) Outside driving rod and slide bar. (19)

Outside coupling rod. (20) Chain drive and valve motion cranks of Bulleid valve gear for all three cylinders, totally encased in an oil-bath. (21) Reversing link motion. (22) Inside driving-crank. (23) Cylinder drain-cocks. (24) Vacuum brake and train-heating connections. (25) All-electric lighting for train codes. (26) Air deflector plates. (27) Air intake for lifting chimney exhaust upwards. (28) Streamlined outer casing. (29) Patent pressed-steel disc wheels. (30) Brake pull-rods. (31) Brake shoe-hangers. (32) Fire-box draught-dampers. (33) Exhaust steam injector for boiler feed-water from tender. (34) Water capacity: 4,500 gallons. (35) Water filler. (36) Coal capacity: 5 tons.

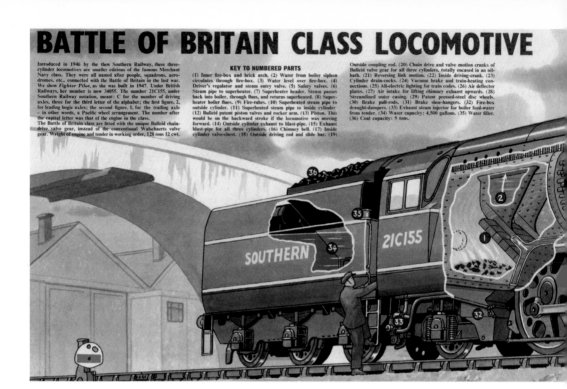

Steam and electrical traction

This classic cutaway from the pages of *The Eagle* comic in 1959 reveals the inner-workings of a Battle of Britain Class locomotive, the appropriately named *Fighter Pilot*. In contrast, the NRM in York houses No. 8143, a Southern Railway 4-Sub Electric Motor Coach, built in 1925 and powered by two Metropolitan Vickers traction units.

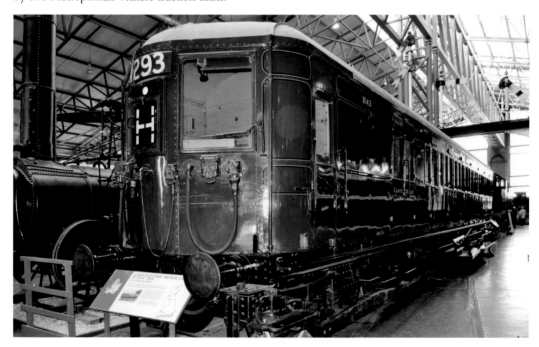

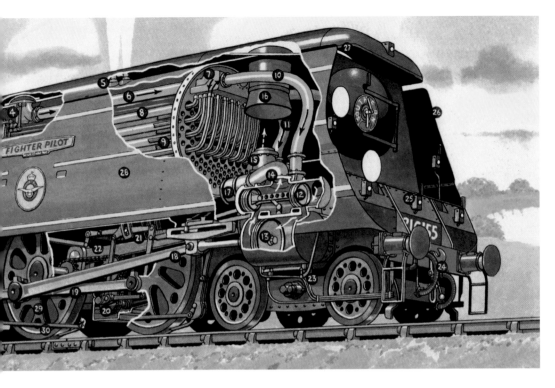

Southeastern 'Networker'

A typical modern EMU or electrical multiple unit, the British Rail Class 465. Built in the 1990s and known as a 'Networker', the 465 is used by Southeastern on its suburban routes throughout the south east. No. 465926 is shown standing at Victoria's Platform 4. The arched roof on this side of the station is hidden by a scaffolding deck during restoration work in 2010.

A unified station

After the grouping of the 'Big Four' railway companies in 1923, Victoria's two stations became one with several of the arches in the diving brick wall opened up and the platforms renumbered starting from the Dover side. Serving the South East and the South Coast, the Southern Railway always had a much higher proportion of passenger traffic than the other three big companies, and this scene from the 1930s shows a crowded concourse on a busy holiday weekend.

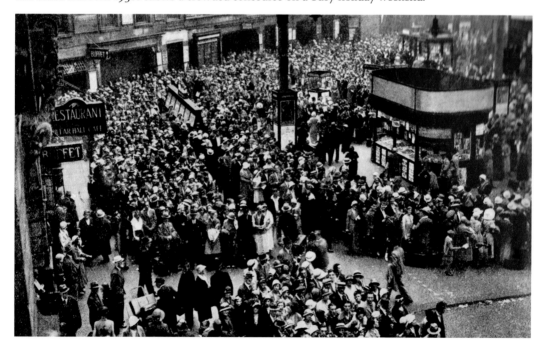

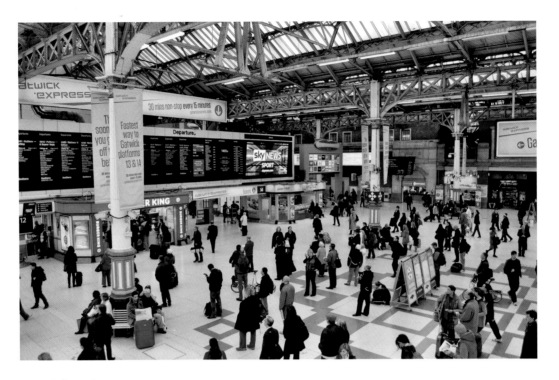

Enlarged concourse area

The concourse area on the Brighton side was dramatically enlarged by moving the end of the rails back to create a bright and airy public area. In the lower picture from around 1960, a former SECR Maunsell Class N 2-6-0 locomotive in British Railways black has stopped alongside the low buildings which were on the edge of the old concourse.

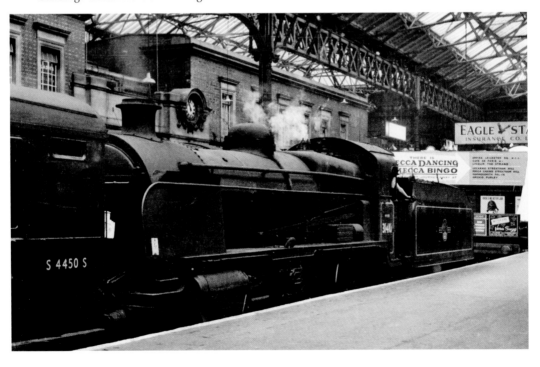

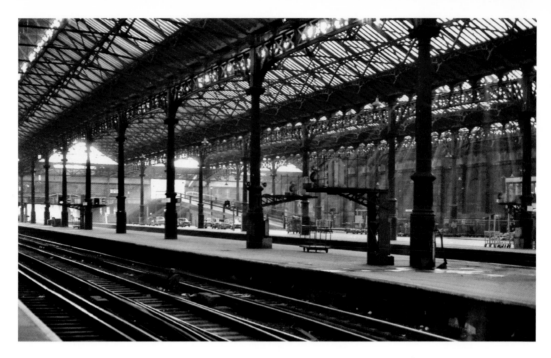

The lost train shed

In the 1976 photograph the LBSCR's south train shed, situated between the Eccleston and Elizabeth bridges, still looked like this. It is a quiet Sunday morning and with the sun streaming through the glass roof you can make out the cab road exit ramp up to Elizabeth Bridge in the background. Sadly, the train shed is now history, demolished and replaced by a massive raft of concrete. Not surprisingly, this part of the station has been described by the original photographer, Pete Hackney, as a 'hideous, dingy, low-roofed warren of modern tiled piers and claustrophobic platforms'.

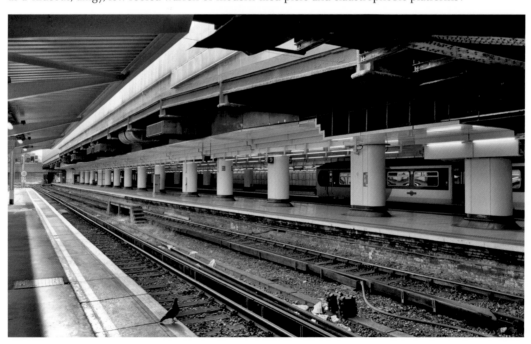

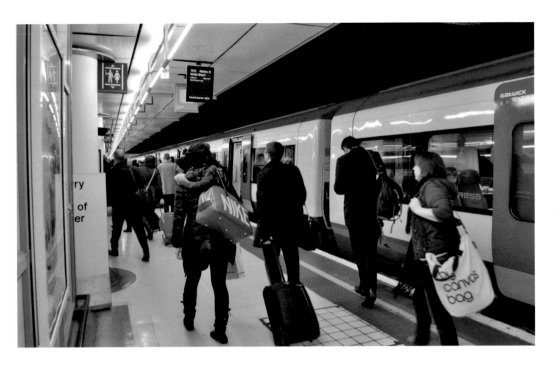

Arrivals on Platform 13

Passengers disembark from the Gatwick Express after arriving at Platform 13 and head off through this subterranean world towards the exits. The Gatwick Express leaves Victoria Station every fifteen minutes and completes the twenty-seven-mile trip to the airport in around thirty minutes. No. 460008 is one of eight Class 460 'Juniper' EMUs on this run. In 2008, several Class 442 'Wessex Electrics' also entered the Gatwick Express service and at peak times these trains go to Brighton. *See page 65.*

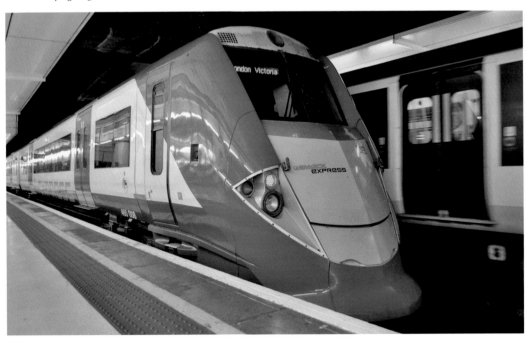

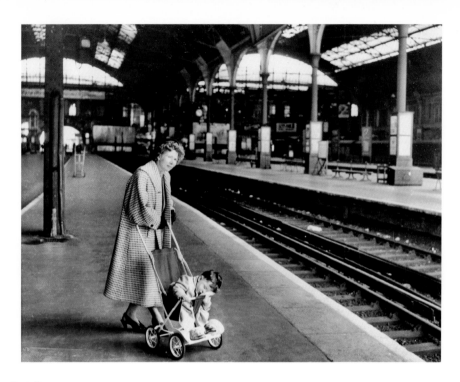

1955 rail strike

The post-war nationalisation of Britain's railways did not always lead to a smoothly run or happy organisation. A major rail strike in 1955 left many travellers stranded, including Lotta Herchy and her fifteen-month-old son shown at Victoria in this press photograph. Strikes still occur from time to time, but today's rail users are more likely to encounter disruption from major refurbishment work and improvement schemes.

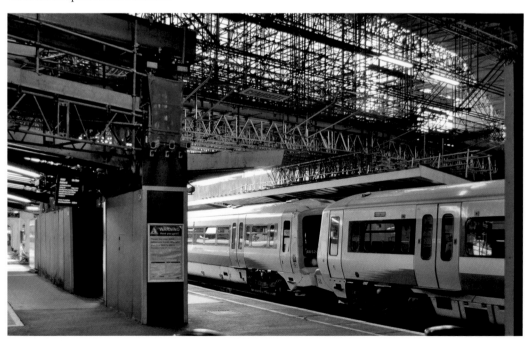

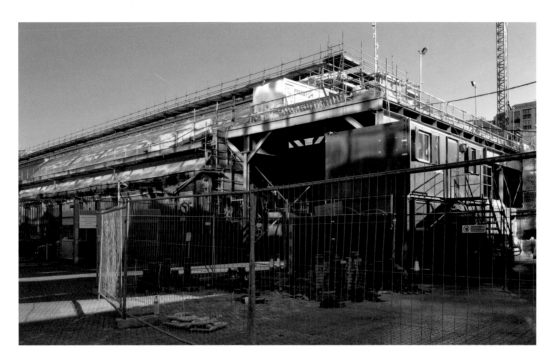

Restoring the roof

Surprisingly, Victoria Station was only granted its Grade II listing status in 2001, although at least this means that the remaining parts of the old station should be protected. In 2008, a £24 million scheme was launched to restore the twin spans of the LCDR roof including stripping down and repainting the metalwork, replacing the wooden purlins with steel, and installing new glazing panels. Once completed the roof should be resplendent in the original Victorian colour scheme, which had become hidden under years of grime and up to thirty layers of paint.

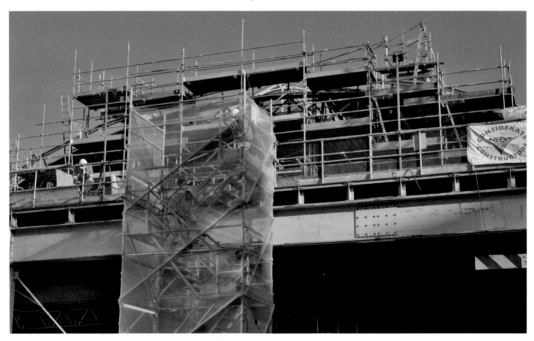

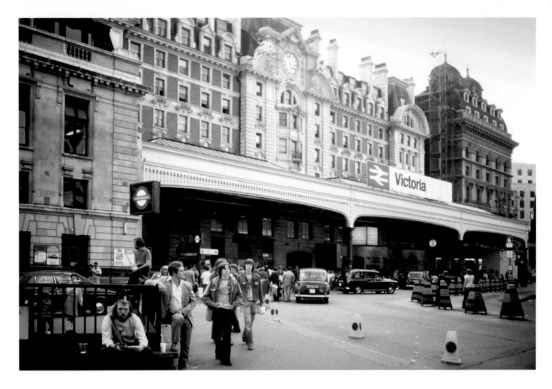

Station exterior

The exterior of Victoria Station has survived remarkably unaltered since the rebuilds at the start of the twentieth century. British Rail did its bit by applying corporate-styled signs, as shown in this 1980s snapshot, but the current version is far more restrained.

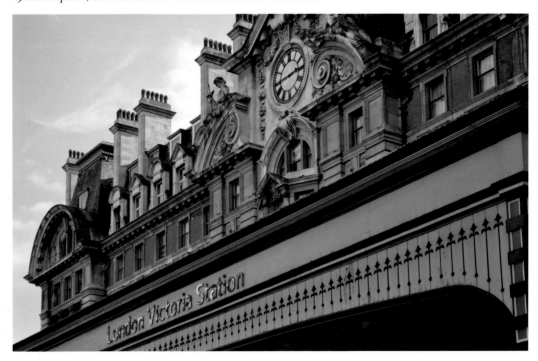

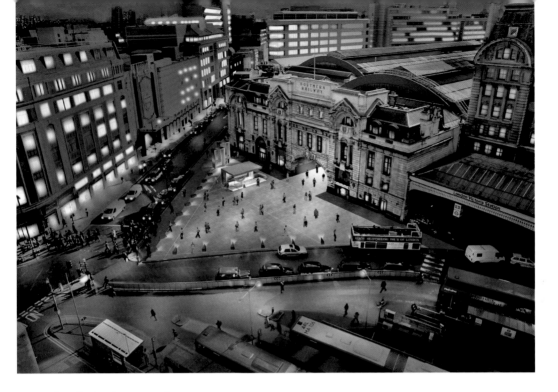

Victoria Station upgrade
A major upgrade to Victoria Underground Station will include the refurbishment of the mainline station forecourt to create a new and less cluttered public space in the former LCDR station yard area. Improvements will also be made to the access to the Underground, such as the 'Sussex Stairs' entrance shown below. (TfL)

Expanding the Underground station

A new North Ticket Hall will be created beneath the junction of Bressenden Place and Victoria Street with an entrance from street level in front of the Cardinal Place building. This will involve the demolition of some buildings beside the Victoria Palace Theatre. Underground connections between the Victoria, District and Circle Line platforms, as well as to the mainline station, will be improved. (TfL)

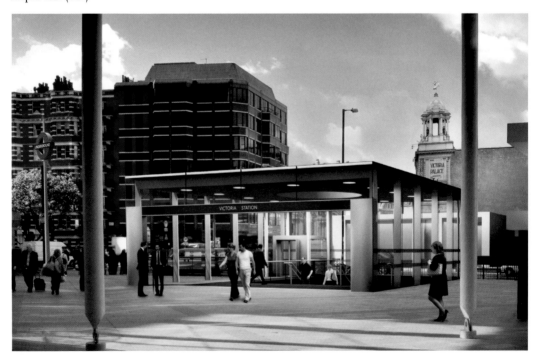

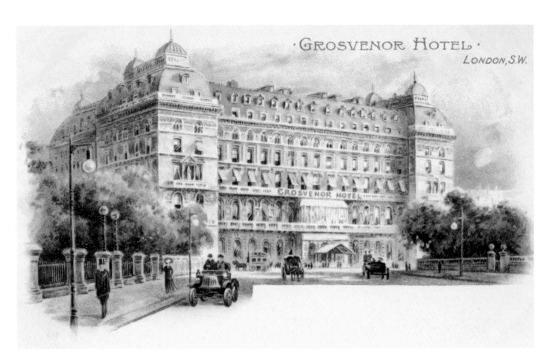

The Grosvenor Hotel

The façade of the Grosvenor Hotel, looking out on to Buckingham Palace Road, has hardly changed since it was completed in 1861. Designed by J. T. Knowles in the Second Empire style it has retained its tall pavilion roofs and when it opened it was declared to be one of the finest hotels in London. As part of the LBSCR station rebuild it was extended over the railway company's new frontage, and today it has 357 bedrooms.

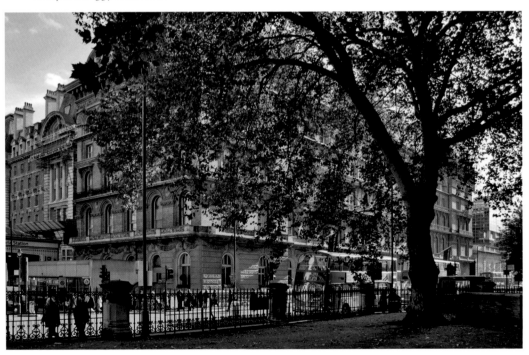

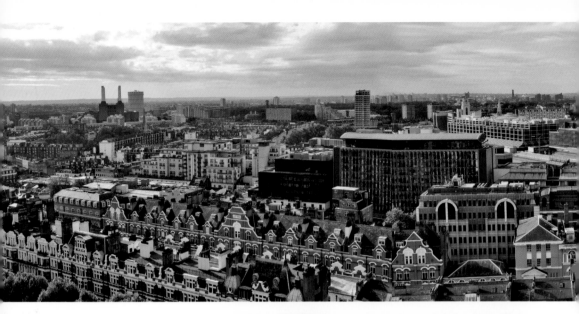

The Victoria area

Seen from the top of Westminster Cathedral's 273-foot-high campanile tower, Victoria's station roof is in the centre with the block of the Victoria Place development just beyond it. In this highly cluttered view the LBSCR frontage and the Grosvenor Hotel are hidden behind the canopied office block on Vauxhall Bridge Road. The chimneys of Battersea Power Station are visible south of the Thames, to the far left. Victoria Street and the Cardinal Place complex are on the far right.

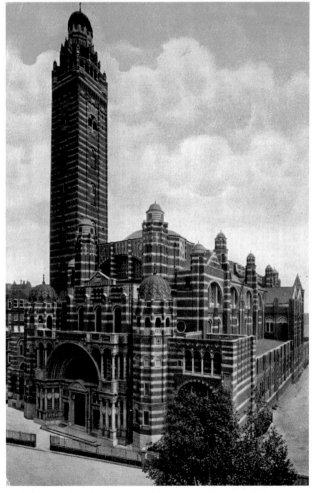

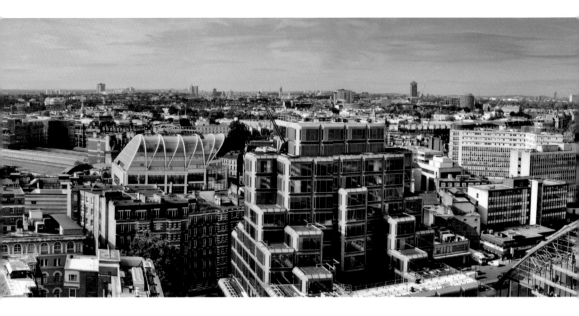

Westminster Cathedral

Opened in 1903, Westminster Cathedral – which should not be confused with Westminster Abbey – is the largest Catholic church in England. The work of architect John Francis Bentley, it is in a Byzantine style with strong redbrick and cream horizontals. The internal space is a great surprise, larger than expected thanks to four great domes, but much darker too. The campanile, or bell tower, is open to the public and accessed by elevator. It offers some of the most breath-taking views to be found anywhere in London. (Photograph by Velela)

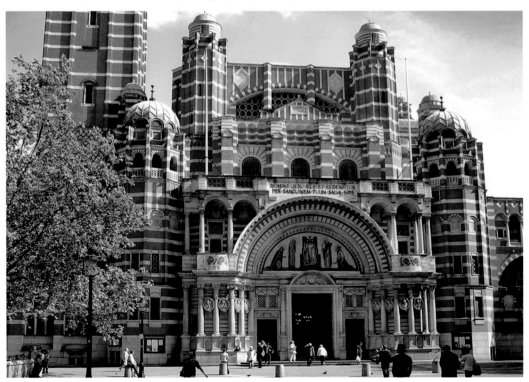

Two local businesses

The Army & Navy Store was one of the most famous retailers on Victoria Street. Founded in 1872 it sold groceries, clothes and guns, and at one time was open only to high-ranking members of the armed forces or their widows. Shown on an advertising card *c.* 1930, the shop is now part of the House of Fraser group. Below is another advertising postcard, this time for the Wilton Hotel adjoining Victoria 'stations', plural, no less.

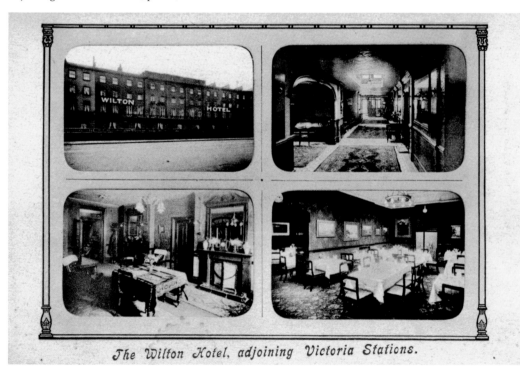

The Wilton Hotel, adjoining Victoria Stations.

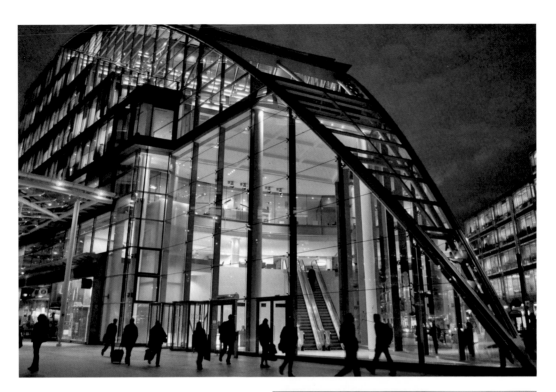

Changing shapes

Two contrasting approaches to office design. Portland House, on the right, was a close copy of the MetLife building in New York, and when completed in 1963 its twenty-nine floors were a monument to modernity. At one time in the 1960s it was the headquarters for British United Airways. Half a century later this skyscraper looks cold and brutal to the modern eye.

By comparison, the 2004 Cardinal Place development is positively whimsical with the Concorde-like droop-snoop of Building One extending down to pavement level on Victoria Street.

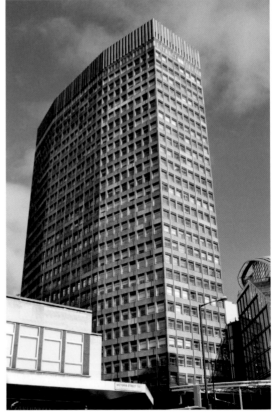

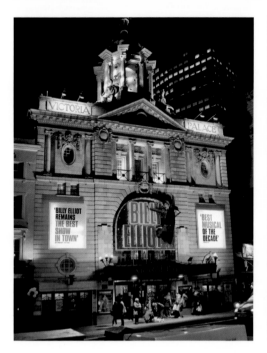
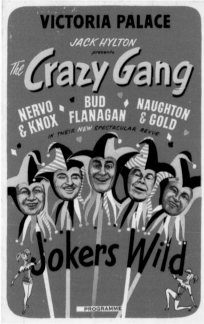

West End theatres

The Victoria Palace Theatre began life as a music hall. Rebuilt in 1911 to a design by Frank Matcham, it is noted for the gold statue of Anna Pavlova perched on the top cupola, although the current figure is only a replica, and as the home of the Crazy Gang. Just across from the Theatre is Little Ben, a 20-foot version of its bigger namesake first erected in 1891 as a mark of Anglo-French friendship.

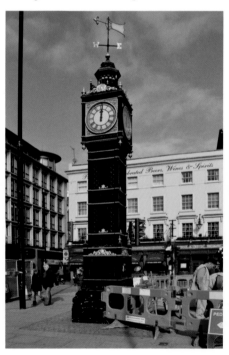

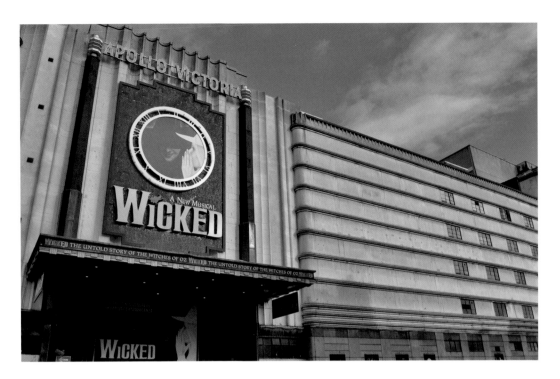

The Apollo Victoria

Designed by architects Ernest Walmsley Lewis and Willian Edward Trent, the Apollo Victoria began life as the New Victoria Cinema in 1930. Unusually, it has two façades, one facing Victoria Station across Wilton Road and another on Vauxhall Bridge Road. Its Art Deco styling is a bold expression of austere modernity with its strong banding, although concealed lighting transforms its appearance after dark. Wicked!

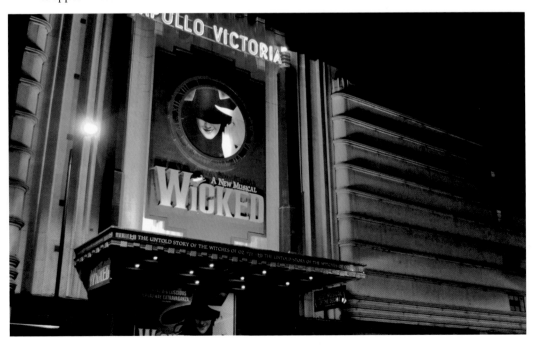

Across the River Thames

Looking north towards Victoria and Belgravia from the Battersea side of the Thames, the entrance into the Grosvenor Canal is straight ahead. To the left is the redbrick of the Lister Hospital on the far side of Chelsea Bridge. The old suspension bridge, constructed in 1851 and named Victoria Bridge, had provided the population of Chelsea with the means to reach the new Battersea Park. The current bridge opened in 1937 and replaced the earlier structure which had become unsound.

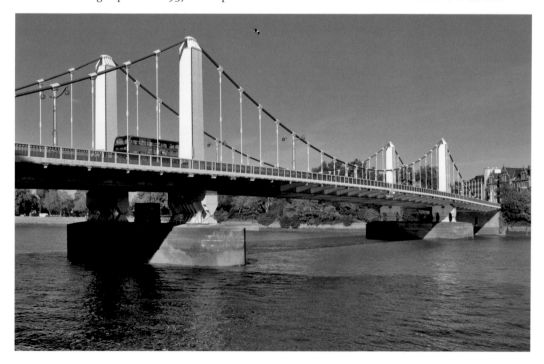

The tall chimney to the right of the canal entrance belongs to the water company's pumping station on Grosvenor Road. It is a wonderfully decorative stack, topped with its own wrought iron railings. On the right is Grosvenor Bridge, the railway bridge, and poking up beyond that you can just make out Portland House and the bell tower of Westminster Cathedral. The Grosvenor Road Carriage Sheds are situated out of view on the far side of bridge.

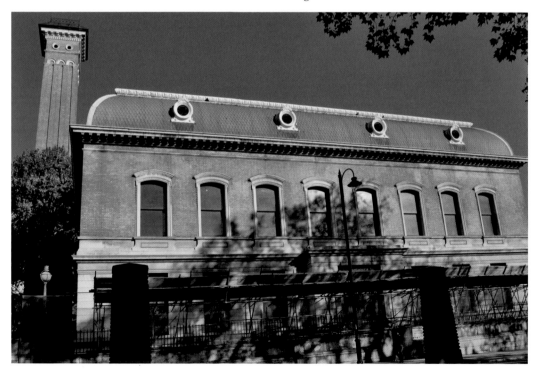

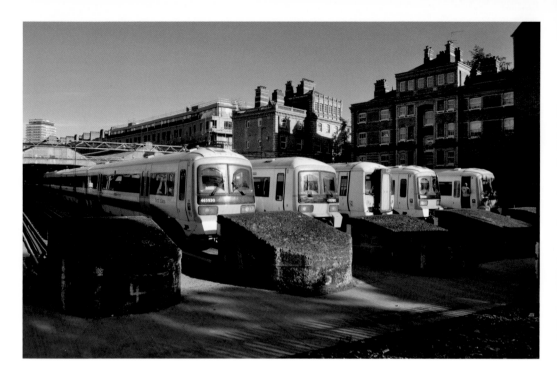

Grosvenor Road Carriage Sheds

A clutch of Southeastern 'Networker' 465 EMUs biding their time in the early morning sun at the Grosvenor Road Carriage Sidings. This is located on the eastern side of the railway lines into Victoria Station, from the Ebury Bridge and down as far as Grosvenor Road on the north bank of the river. The huge concrete blocks are there to prevent runaway trains joining the cars on the main road. *See page 75.*

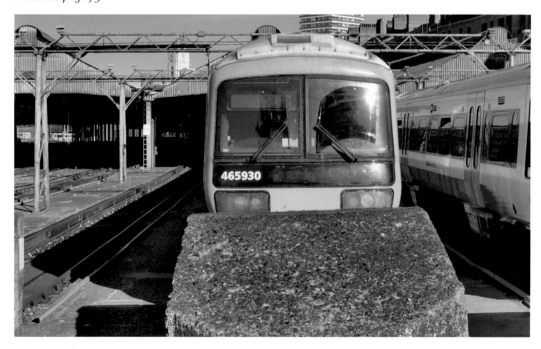

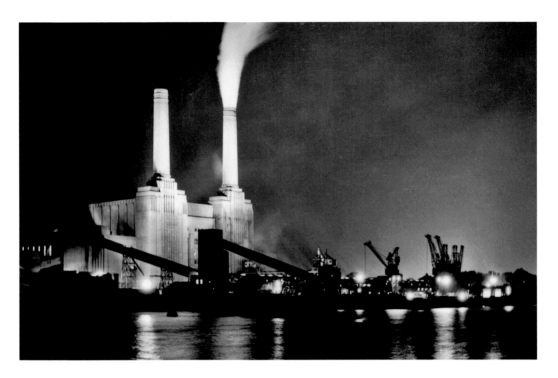

Battersea Power Station
The upturned table legs of the old power station still dominate the skyline in this part of London. Built in two stages, in the 1930s and 1950s, it continued to generate electricity until 1983. Since then it has been stripped to an empty shell, achieved international fame on the cover of a Pink Floyd album, but as yet no permanent use has been found for what is Europe's largest brick building. In the lower image it looms over the Grosvenor Road Carriage Sheds.

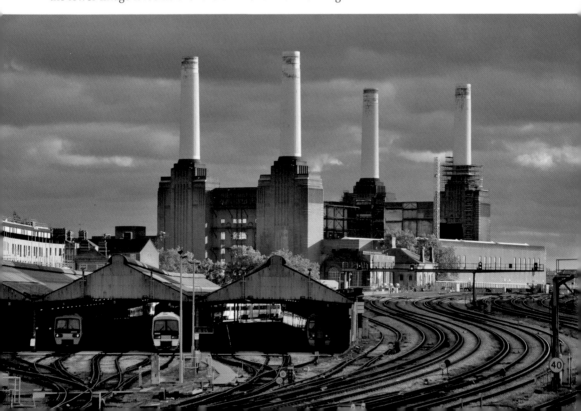

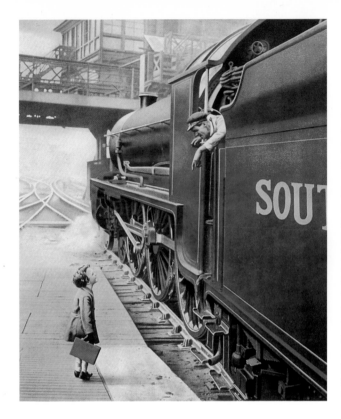

The sunshine line
'I'm taking an early holiday cos I know summer comes soonest in the south.'

This classic image of the little boy talking to the train driver appeared on Southern Railway's most famous advertising poster. There were several versions, another read, 'For holidays I always go Southern cos it's the Sunshine Line.' It was so popular that the LNER produced its own pastiche on the poster, but they couldn't match Southern's claims on sunshine. Not quite Victoria as the photo was actually taken at the SR's other London terminus, Waterloo.

Acknowledgements

I would like to acknowledge and thank the many individuals and organisations who have contributed to the production of this book. In particular Campbell McCutcheon of Amberley Publishing for coming up with the idea of including this treatment of Victoria Station within the 'Through Time' format as a follow up to *Paddington Station Through Time*.

Unless otherwise credited almost all new photography is by the author. Additional images have come from a number of sources and I am grateful to the following photographers: Nick Fowler, Peter Skuse, Andy Vetch, Arriva436, Damon Hart-Davis, Pete Hackney and Velela. Of the various organisation I must thank Robert Excell of the London Transport Museum (Transport for London), also the US Library of Congress, the 5BEL Trust and Network Rail.

Final thanks go to my wife Ute Christopher who assisted with proof reading, and to our children Anna and Jay. Apologies to anyone left out unknowingly and any such errors brought to my attention will be corrected in subsequent editions. JC